C000122348

POSH DOGS

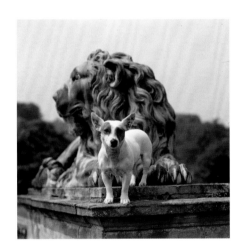

PREVIOUS PAGE: Shufti, a Jack Russell
and *Country Life* cover girl.
RIGHT: English setter

Pimpernel Press Limited
www.pimpernelpress.com

Posh Dogs
Copyright © Pimpernel Press Limited 2016
Photographs copyright © Country Life 2016
First Pimpernel Press edition 2016
Designed by Becky Clarke

All rights reserved. No part of this
publication may be reproduced, stored in a
retrieval system, or transmitted, in any form,
or by any means, electronic, mechanical,
photocopying, recording or otherwise,
without the prior written permission of the
publisher or a licence permitting restricted
photocopying. In the United Kingdom
such licences are issued by the Copyright
Licensing Agency, Saffron House, 6–10 Kirby
Street, London EC1N 8TS.

A catalogue record for this book is available
from the British Library.

ISBN 978-1-910258-76-7

Typeset in Gill Sans
Printed and bound in China

9 8 7 6 5 4 3 2 1

Photographer credits Matt
Barnard 11; Lee Beel 2, 82–3, 94–5;
Clive Boursnell 26 (left), 37; Ian
Bradshaw 24; Val Corbett 22–3,
74, 84 (left), 105 (right); Catherine
Cotton 10, 56, 76; Davin Dhillon
100 (left); Jake Eastham 13, 35;
Mark Fairhurst 27, 38–9, 62–3;
Sarah Farnsworth 36 (right), 49,
54–5, 58–9, 71 (left), 72 (far left),
79, 102–3; David Giles 70; Martyn
Goddard 44–5, 93, 106–9; Gavan
Goulder 72 (left), 73; Frank Griggs
53; John Grossick 33, Craig Knowles
41; Brendan MacNeil 86–7; Trevor
Meeks 20 (right), 21; John Millar
back cover (left); 6–7, 15–19, 66– 7,
71 (right), 80 (right), 85 (left), 88–9,
96–9, 104–5 (left), 110–111; Brian
Moody title page; 8, 9, 34, 57, 78;
Jerome Murray 112; Julian Nieman
25; Charles Sainsbury-Plaice front
cover; back cover (middle and
right), 14, 26 (right), 28–9, 46–8,
64–5, 68–9, 77, 81 (left), 92;
Glyn Satterley 12, 40, 50, 80 (left),
85 (right), 90–1, 100 (right), 101;
William Shaw 30, 32; Alex Starkey
75; Paul Quagliana 20 (left), 31, 36
(left), 81 (right); Charlotte Winn 51.

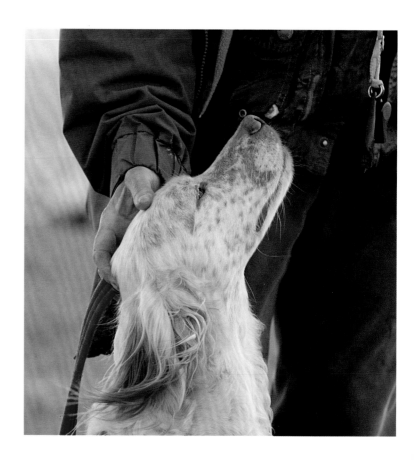

POSH DOGS

PIMPERNEL
PRESS LTD
www.pimpernelpress.com

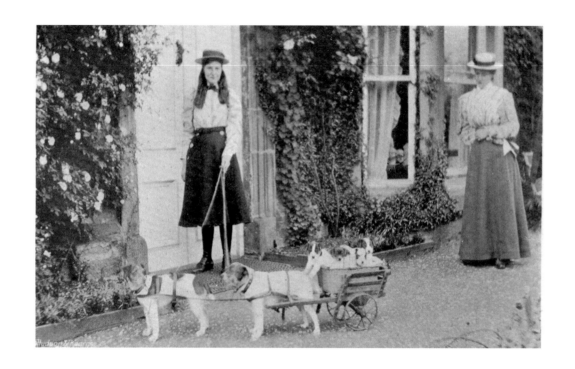

Dog pulling puppies in a cart, c.1900.

INTRODUCTION

Dogs have been at the heart of *Country Life* magazine ever since it was first published in 1897. The very first issue on January 8 featured the Princess of Wales with her borzoi, Alex. The second issue, a week later, went behind the scenes of the Prince of Wales's kennels. Since then all breeds, whether working dogs, pampered pets, champion pedigrees or mixed breeds, have been included. There is no doubt that dogs, whatever shape or size, are at the heart of British country life.

Posh Dogs features a selection of canines that have graced the pages of *Country Life* magazine from those early years to the present day. They have been chosen to select different facets of country life and whether 'upstairs' and 'downstairs' they are all equal in their owner's eyes. *Posh Dogs* celebrates dogs in their element amidst the timeless beauty of the British countryside.

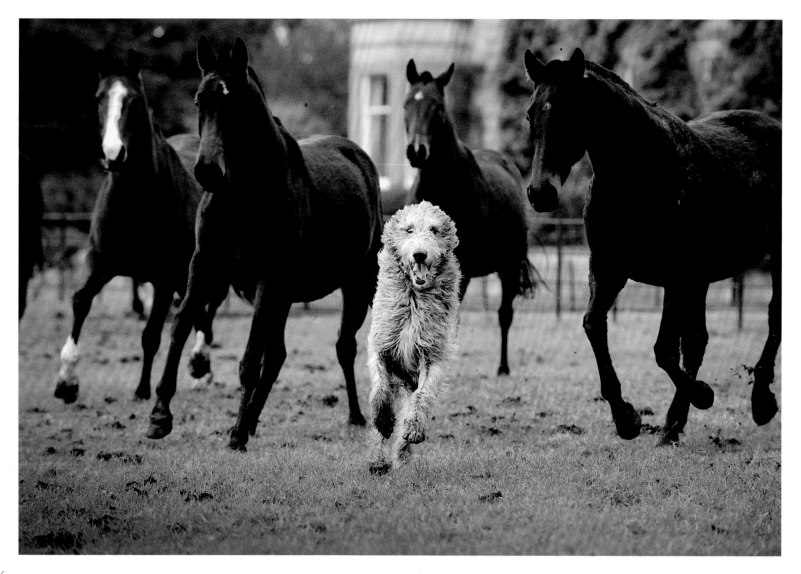

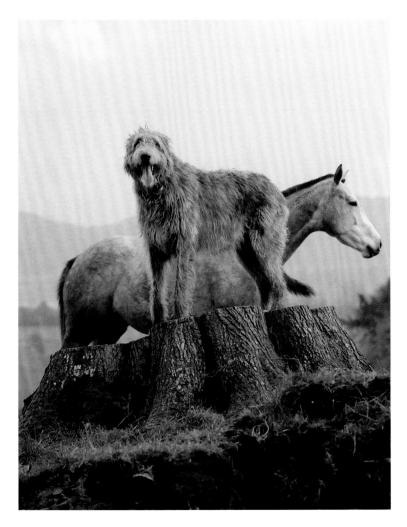

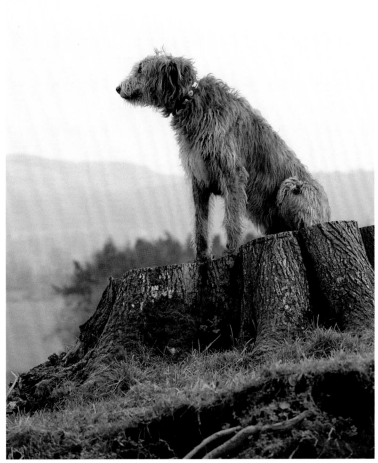

Irish wolfhound, Wolfie, and polo ponies at Errol Park, Perthshire

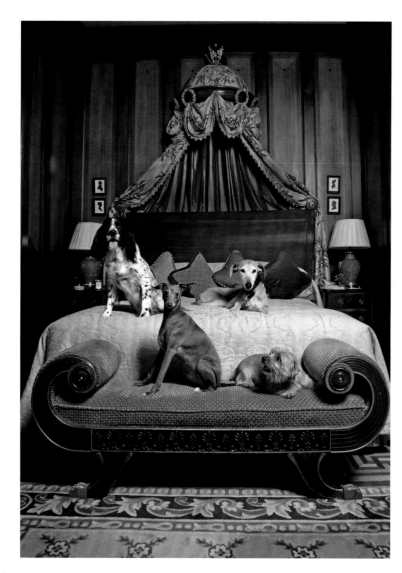

Bramble, a springer spaniel, Bertie, an Italian greyhound, Teasle, a lurcher and Beetle, a Norfolk terrier, at the Lanesborough Hotel, London

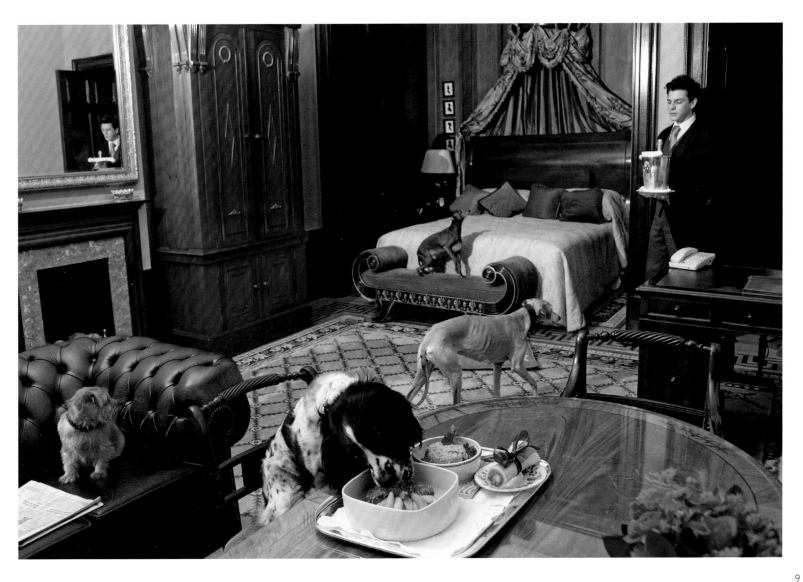

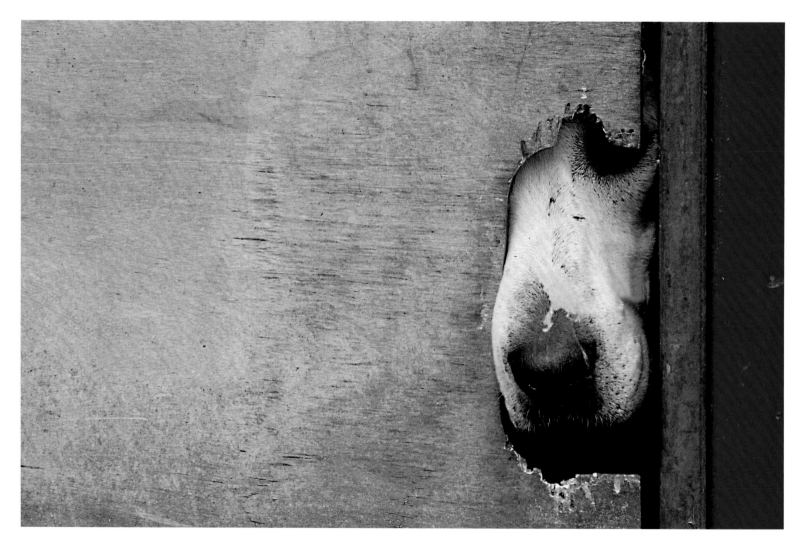

A hound pokes his nose through a gap in the door at the Peterborough Royal Foxhound Show.

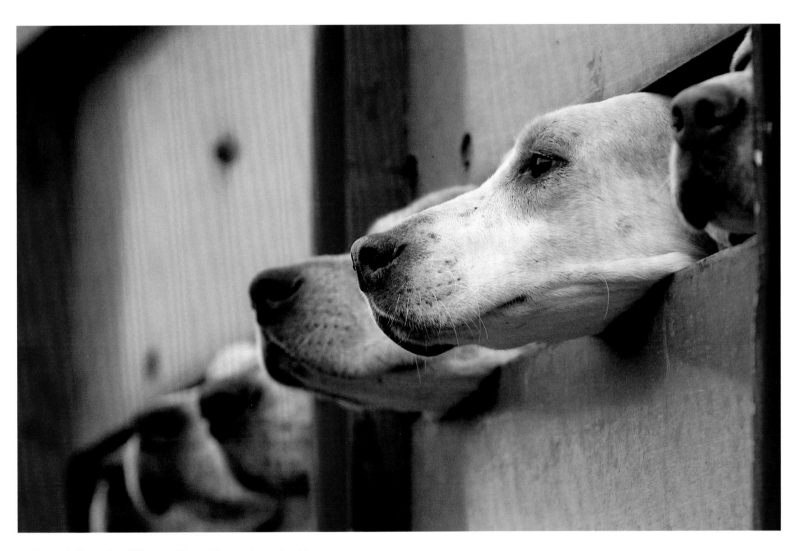

Foxhounds from the Clifton on Teme Hunt, Worcestershire

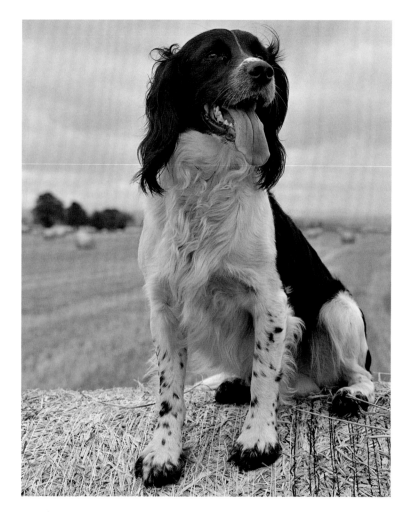

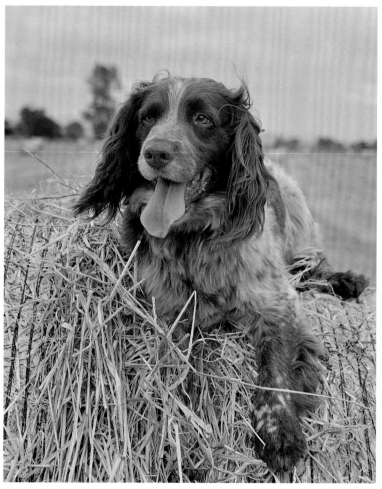

Perthshire-based gun dog, Jura, a sprocker (English springer spaniel/cocker)

ABOVE: A sprocker gundog, Perthshire
RIGHT: Grouse shooting

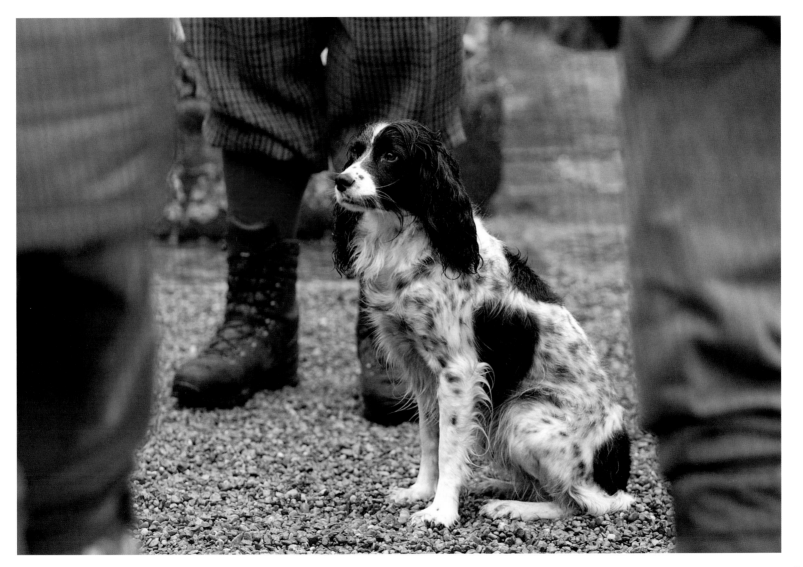

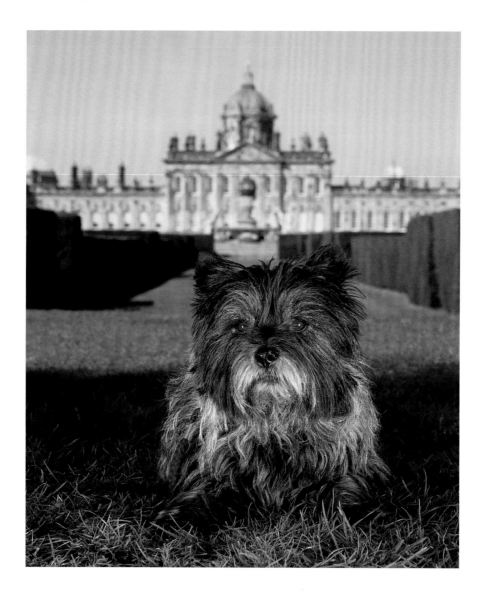

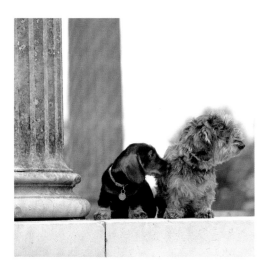 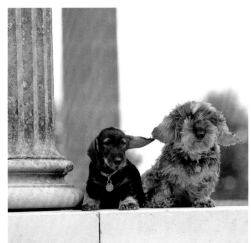 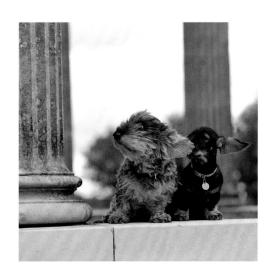

ABOVE: Hattie, a wire-haired standard dachshund and Hester, a smooth-haired dachshund
LEFT: Terrier at Castle Howard, Yorkshire

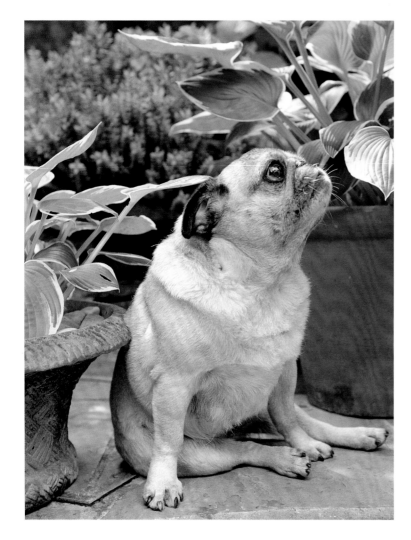

Maud, pug

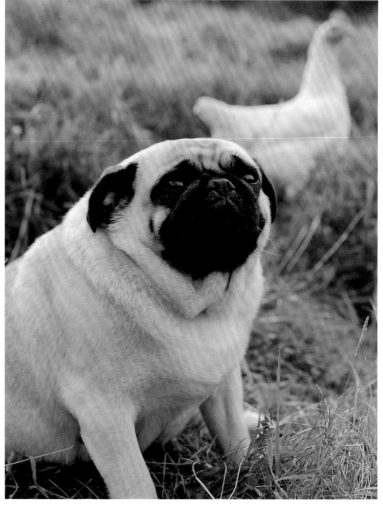

ABOVE AND RIGHT: Bingo, pug

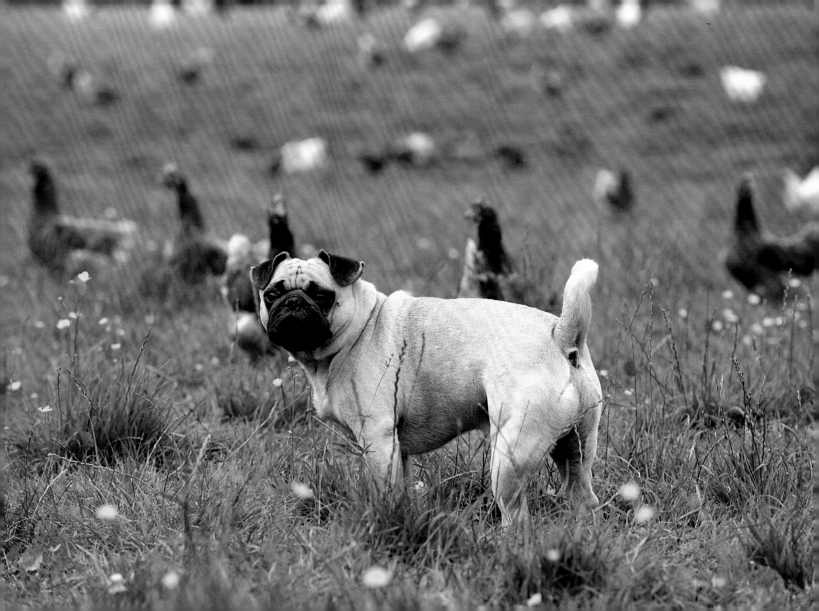

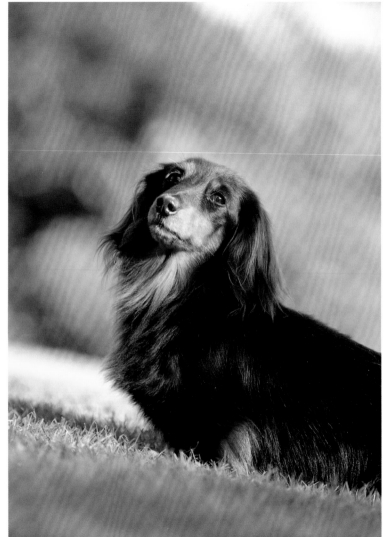

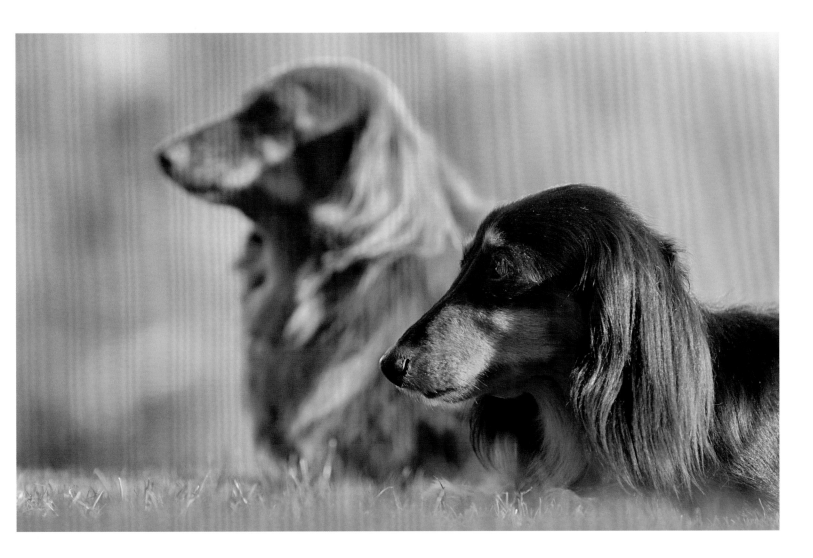

Miniature long-haired dachshunds

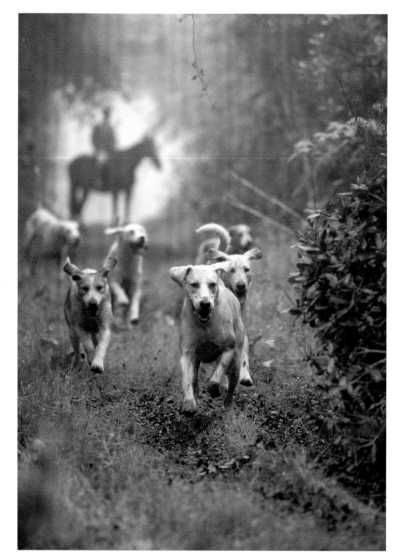
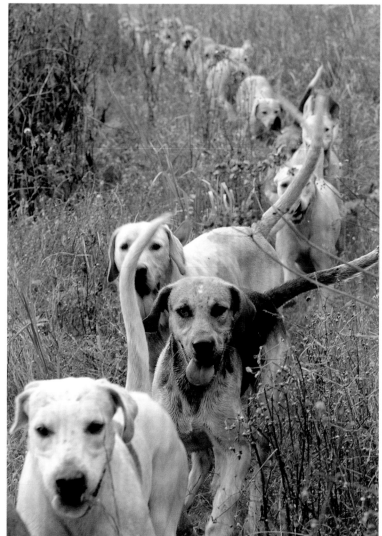

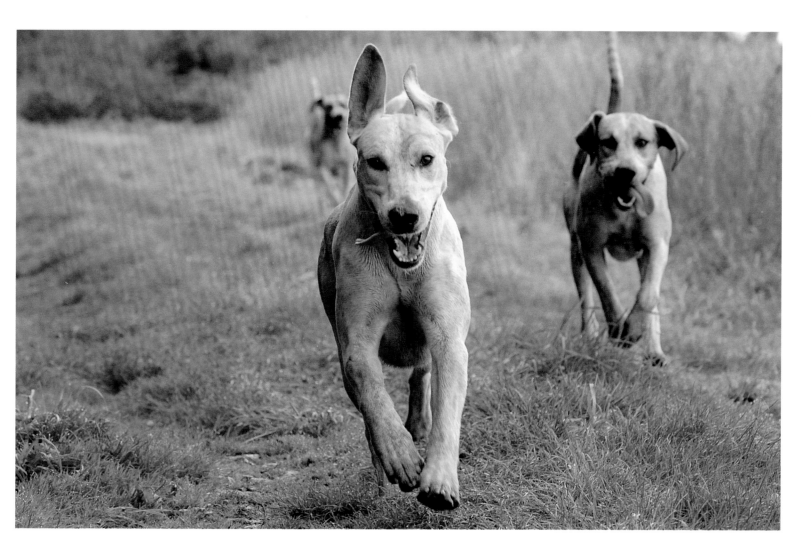

Foxhounds enjoying the chase during Chipstable Hunt and the Blankney Hunt.

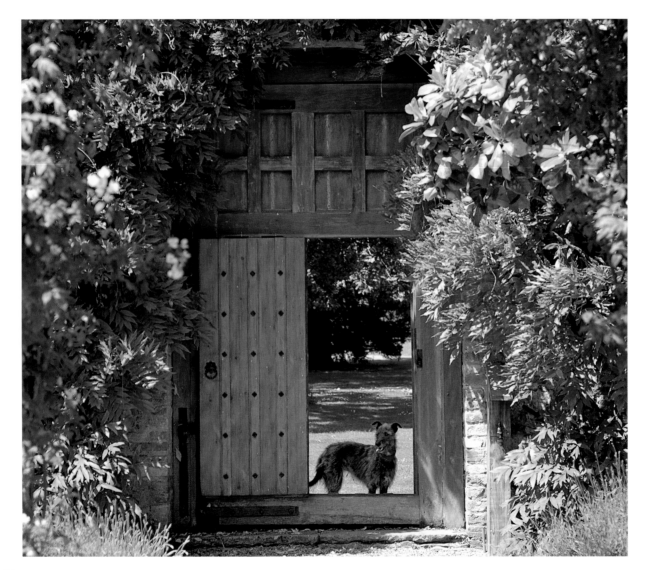

Milly, the lurcher, Stow
Hall, Norfolk

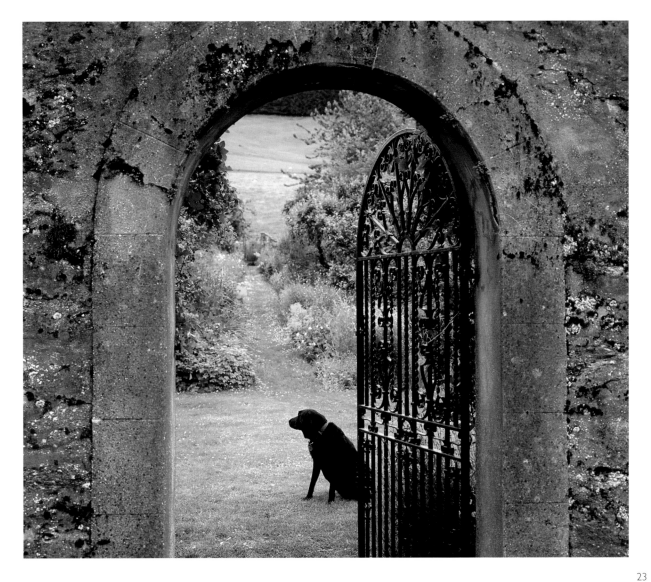

Black labrador, Strathgarry
House, Perthshire

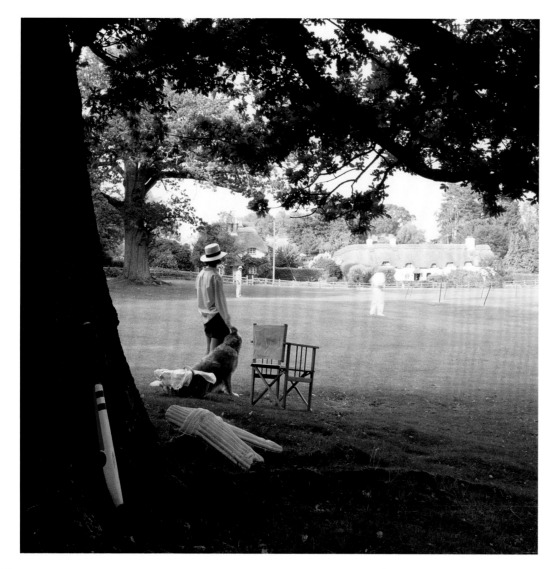

LEFT: Cricket on Swan Green in Lyndhurst, Hampshire

RIGHT: Taking it easy in the garden at Fritham Lodge, Hampshire.

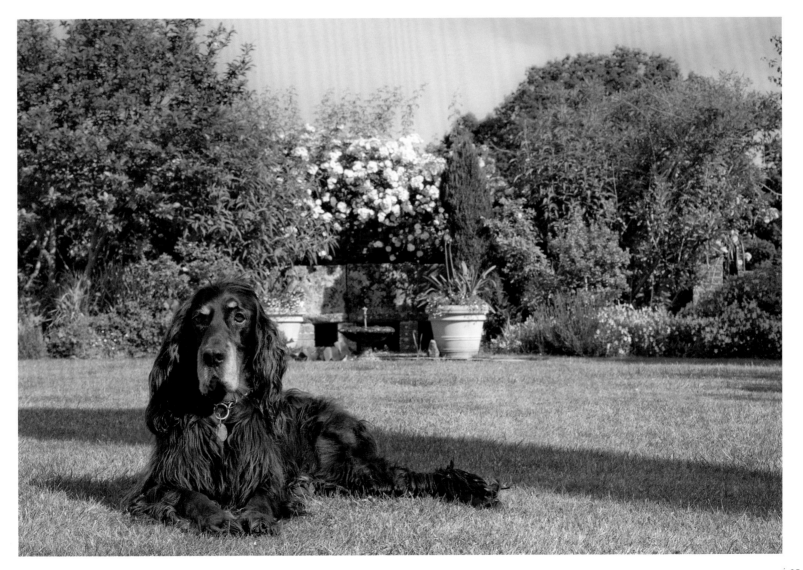

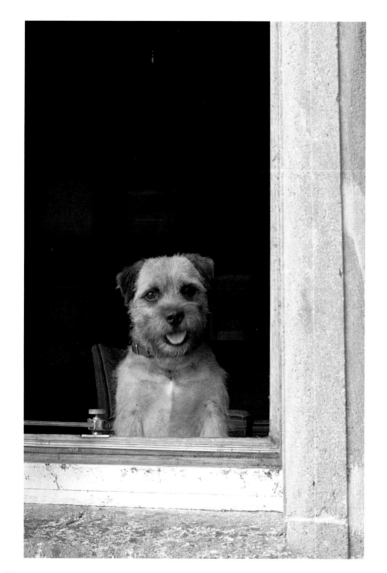
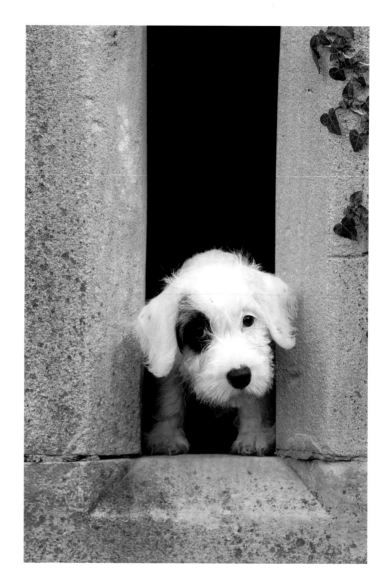

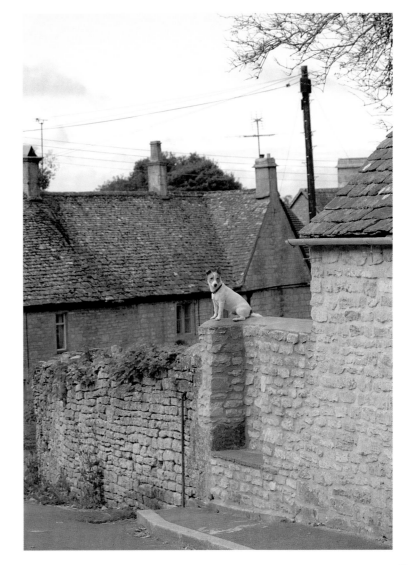

FAR LEFT: Border terrier
LEFT: Sealyham terrier puppy
RIGHT: Jack Russell, Bisley, Gloucestershire

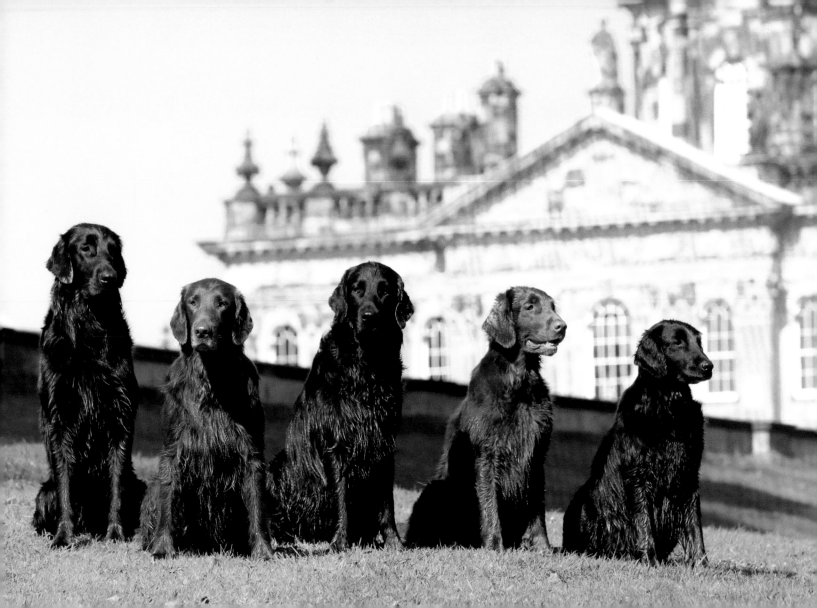

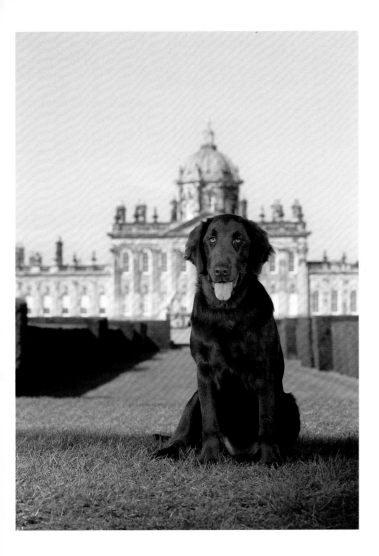

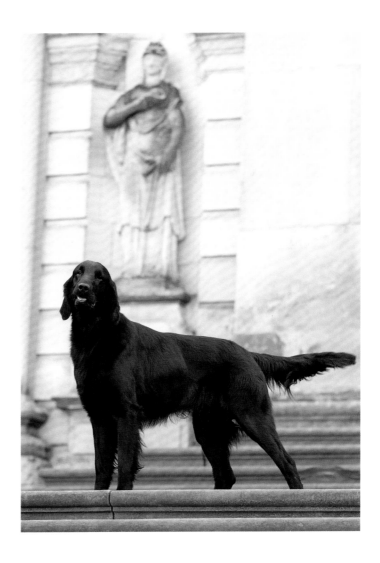

Flatcoat retrievers at Castle Howard, Yorkshire

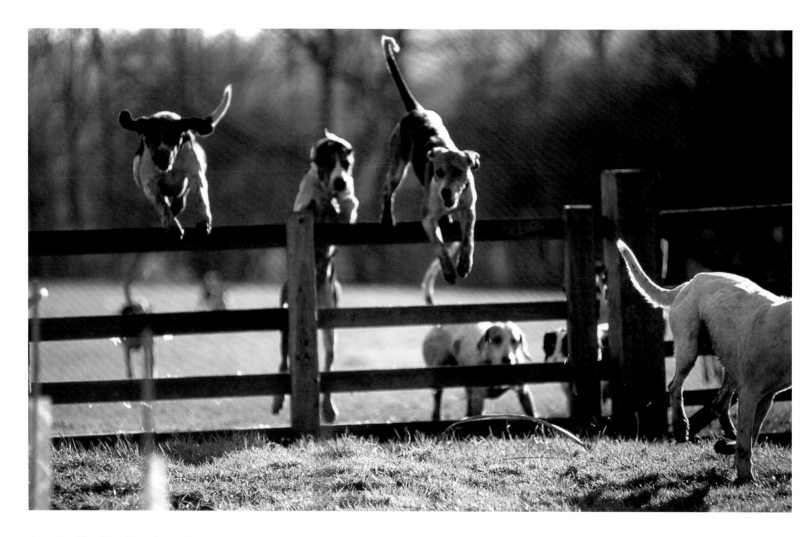

A pack of Pytchley Hunt hounds jump a fence. The hounds are modern English with infusions from Limerick.
RIGHT: A pack of foxhounds from the Britannia Beagles

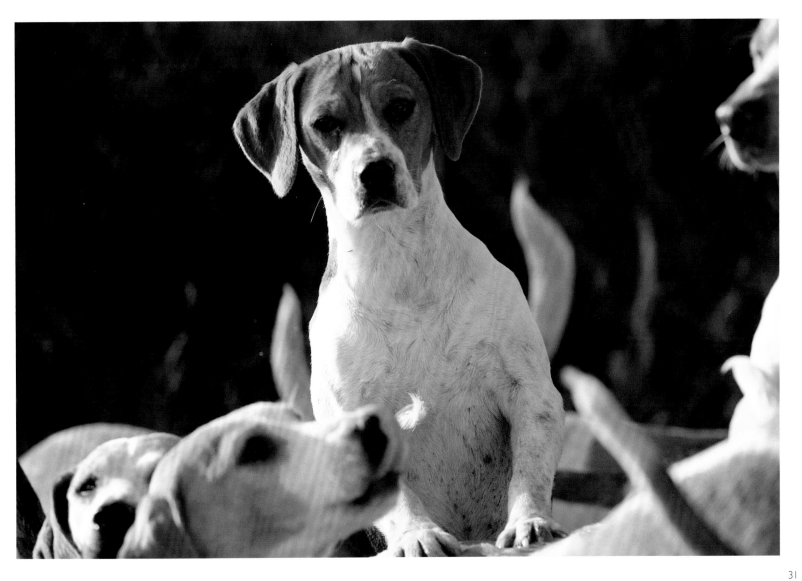

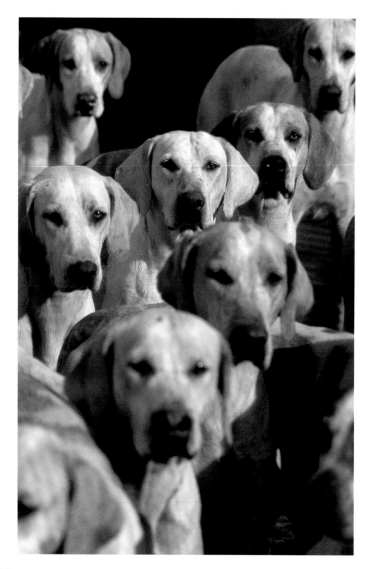

Hounds from the Cheshire Hunt
RIGHT: A pack of foxhounds during the College Valley and Northumberland Hunt

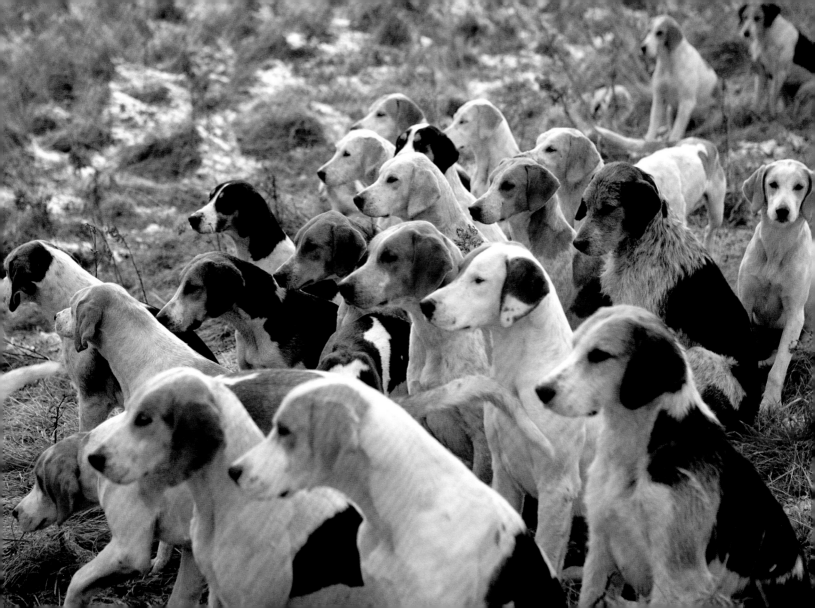

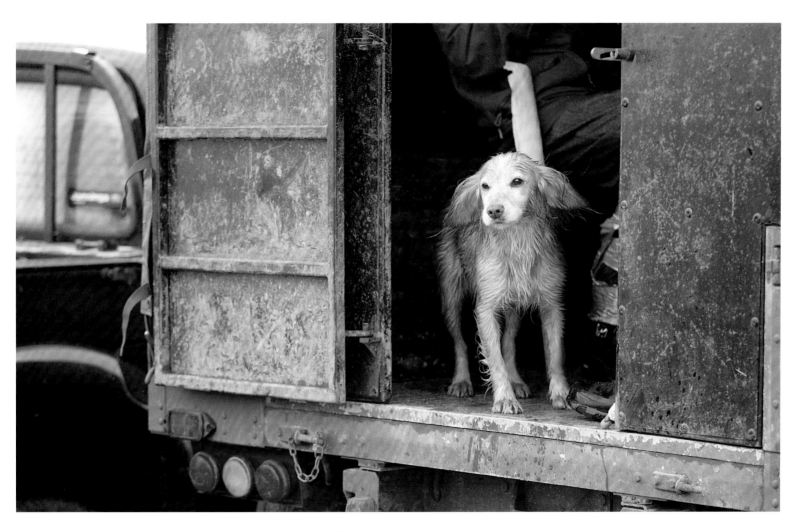

LEFT: Joe, working sheepdog at Gorse Bank Farm, East Grinstead, West Sussex
ABOVE: Gun dog on a grouse shoot

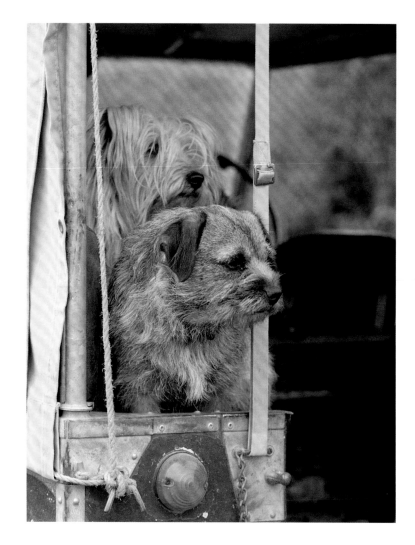

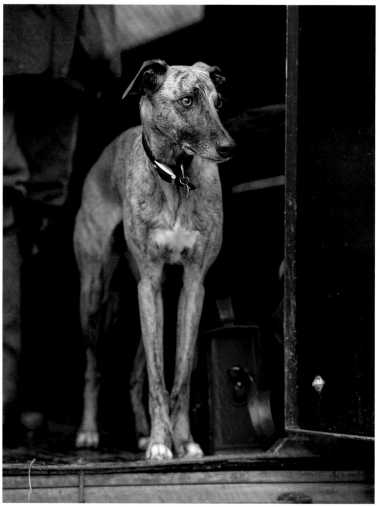

Border terrier

Lurcher

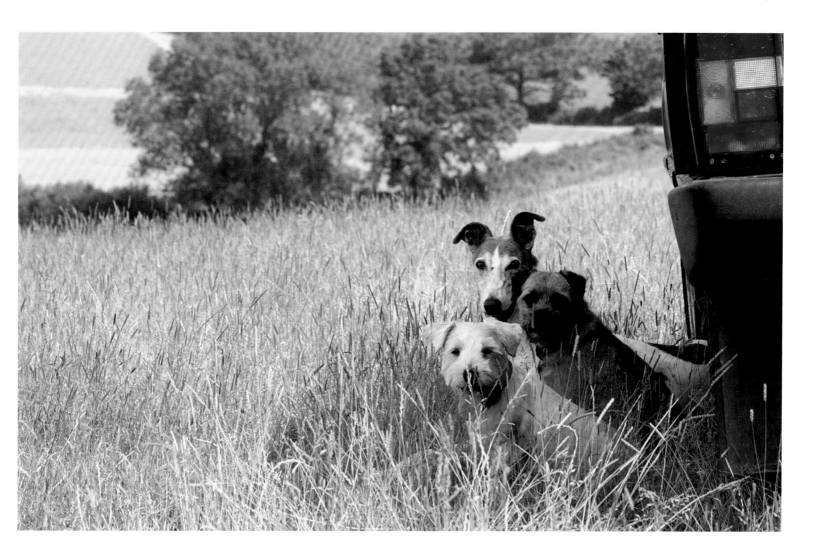

A border terrier and other dogs

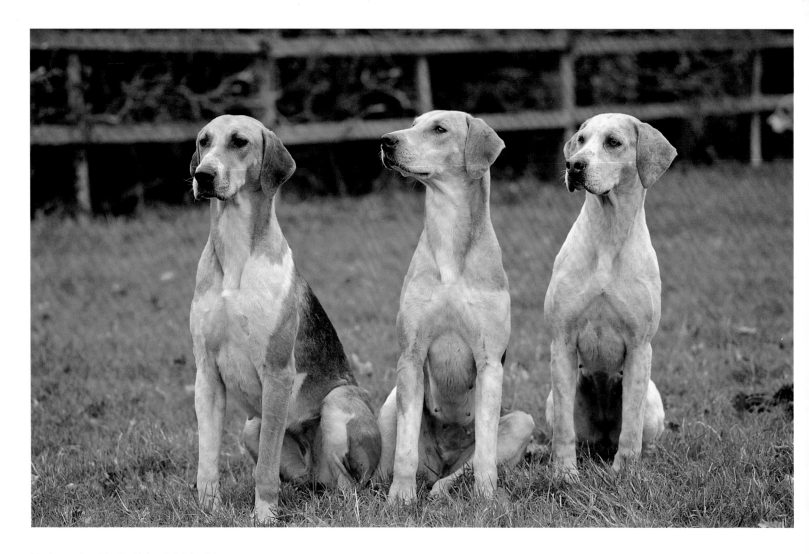

Foxhounds with the Warwickshire Hunt

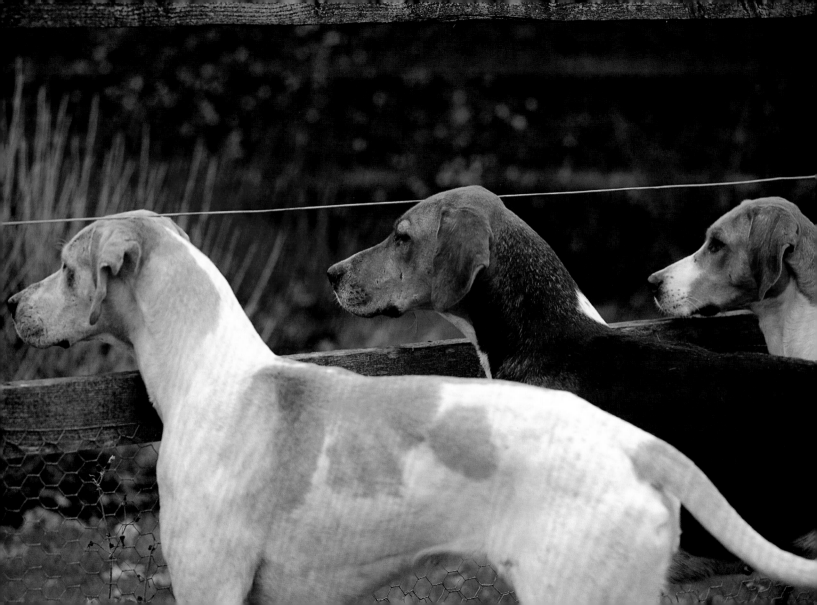

Dandie Dinmont

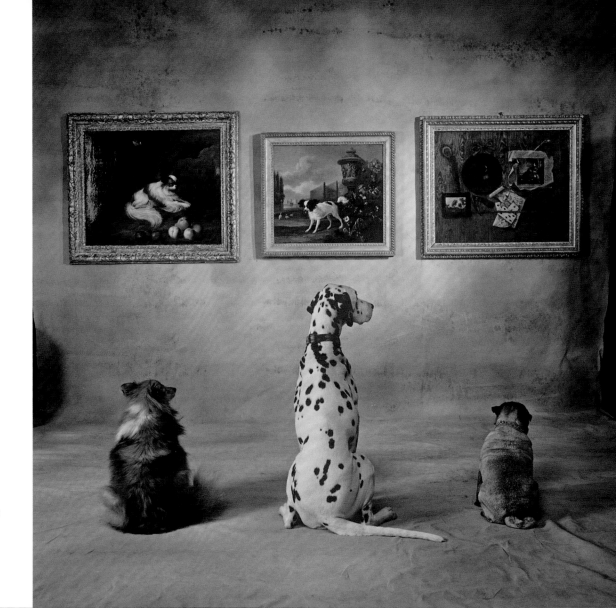

Nina (a Sheltie), Domino (a dalmation) and Mopsie (a pug) contemplate their ancestors as they look at paintings at Christie's auction house; (l-r) Bogdani's *Papillon Dog in a Landscape*, *Spaniel in a Park* and *Trompe L'oeil* by Antonio Scarpetta

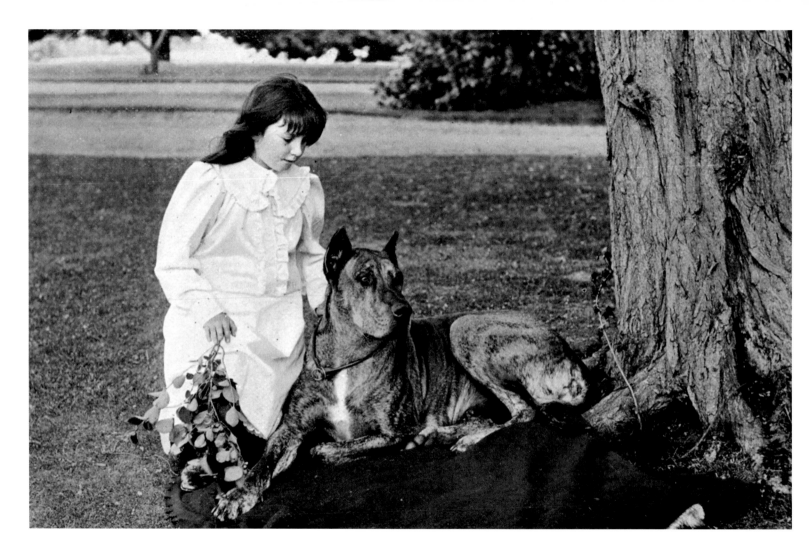

A little girl sits under a tree with a Great Dane, c.1900.

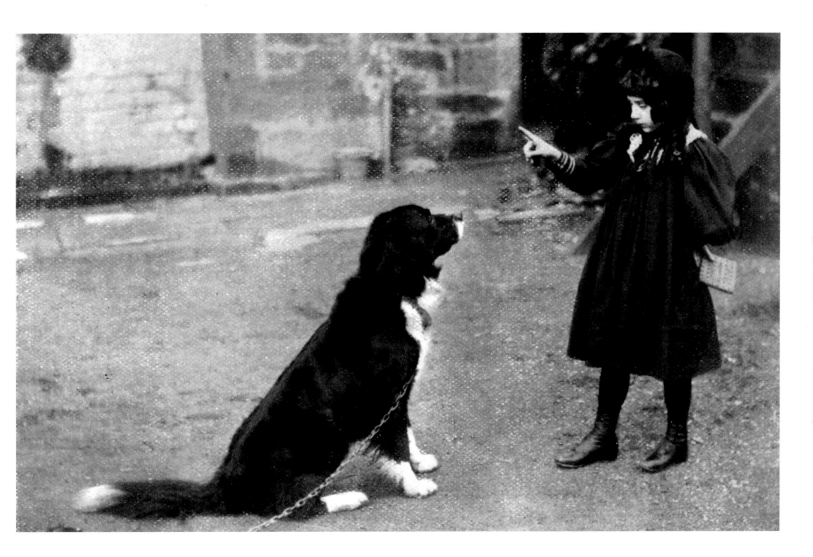

A young girl teaching her dog tricks, 1900.

LEFT: A spanador (spaniel labrador cross)
RIGHT: Megan, labrador

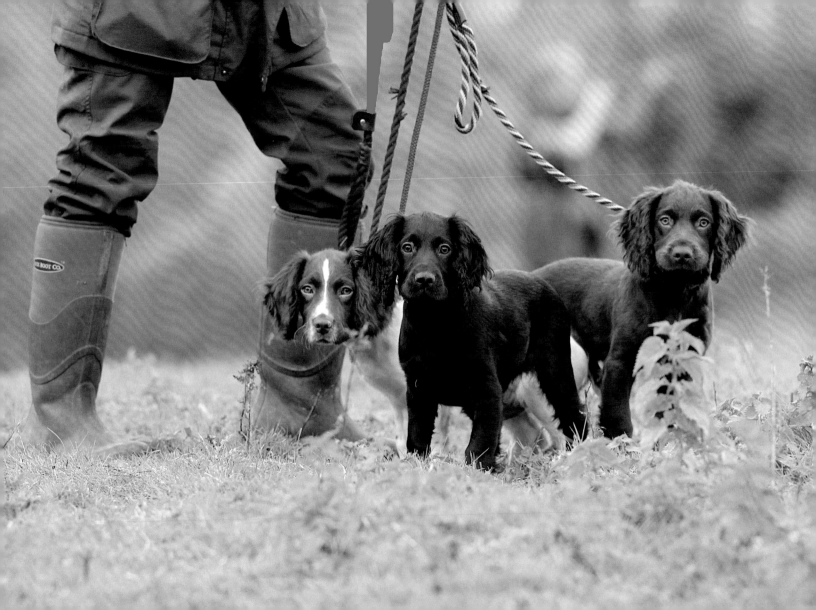

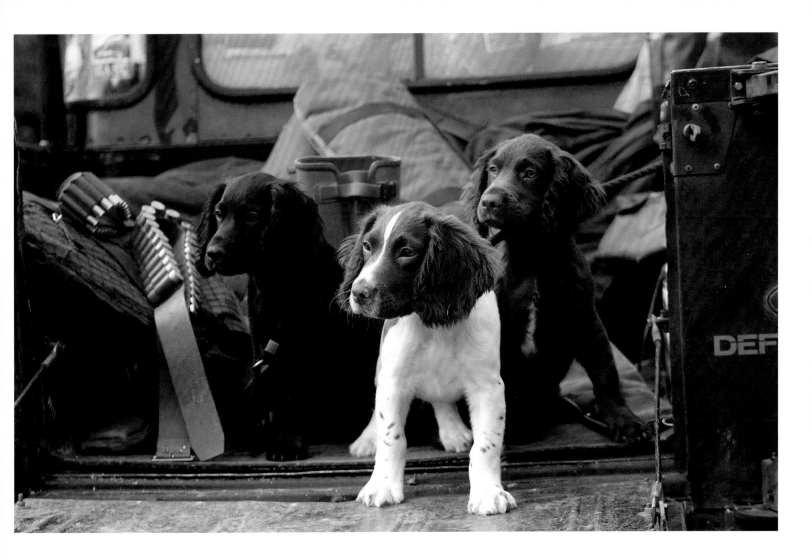

Milo, Fingal and Cocoa, cocker spaniel puppies

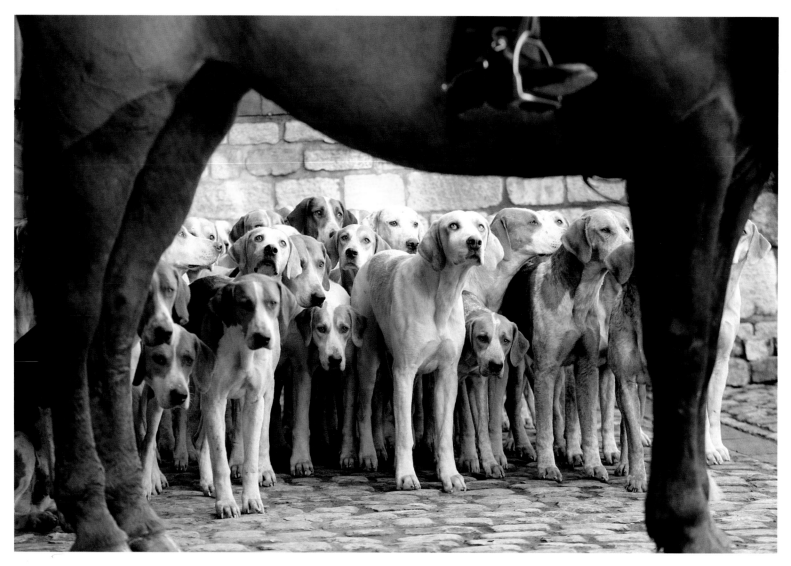

LEFT: A pack of foxhounds during the Berkeley Hunt
RIGHT: Lurcher

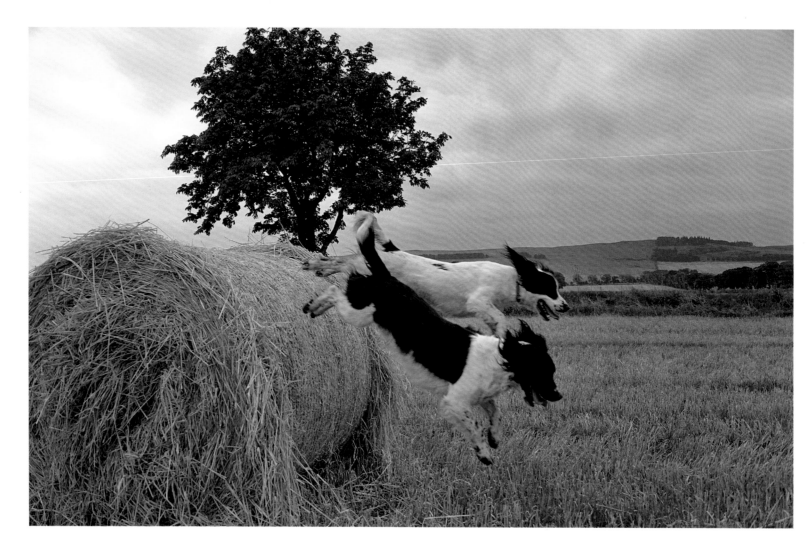

Perthshire-based sprockers (English springer spaniel/cocker), Jura and Uist

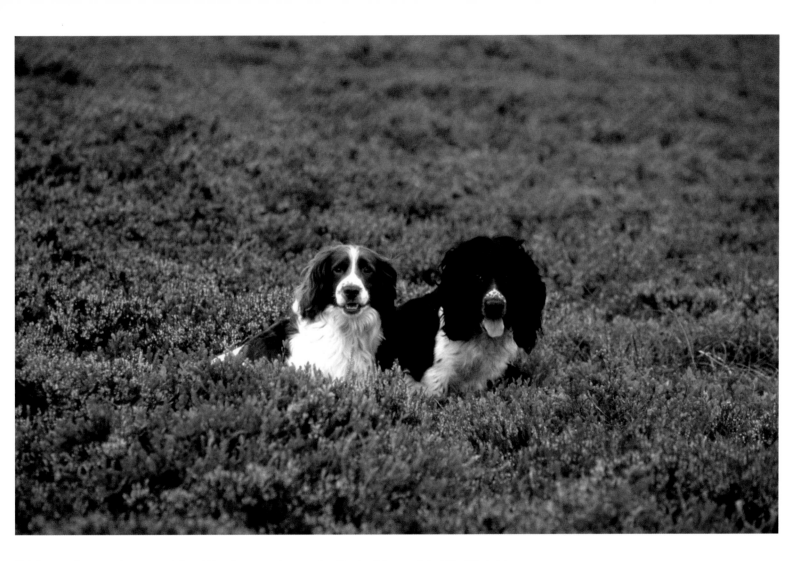

Ralph, a pedigree springer spaniel and Brock, a sprocker, on the Bingley Moor estate, West Yorkshire

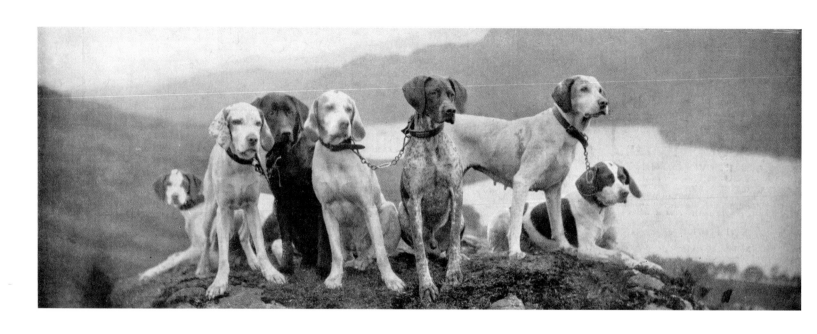

Working dogs on duty
RIGHT: Greyhound puppies at The Homestall kennels, East Grinstead, Sussex, *c.*1933

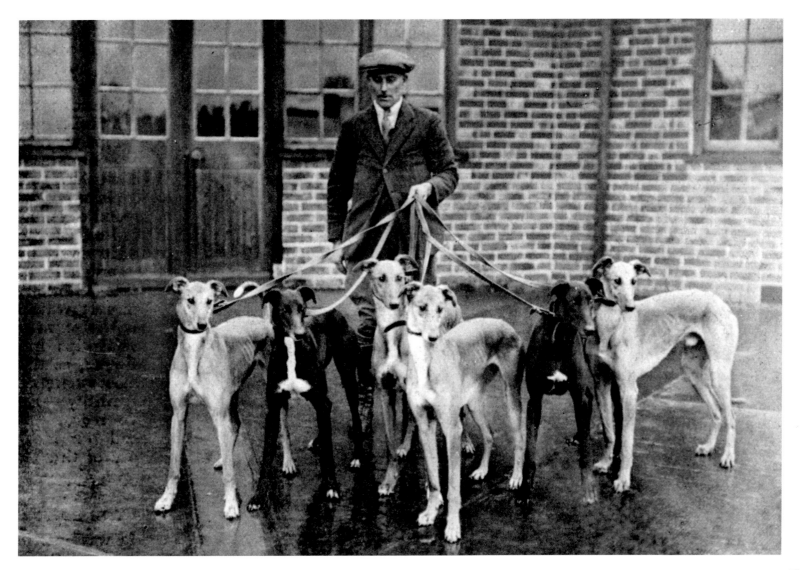

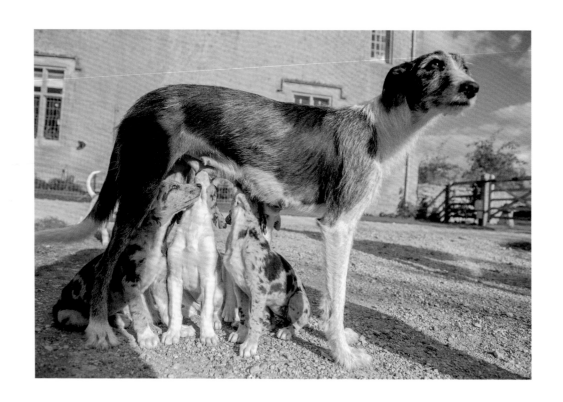

Lurcher with puppies

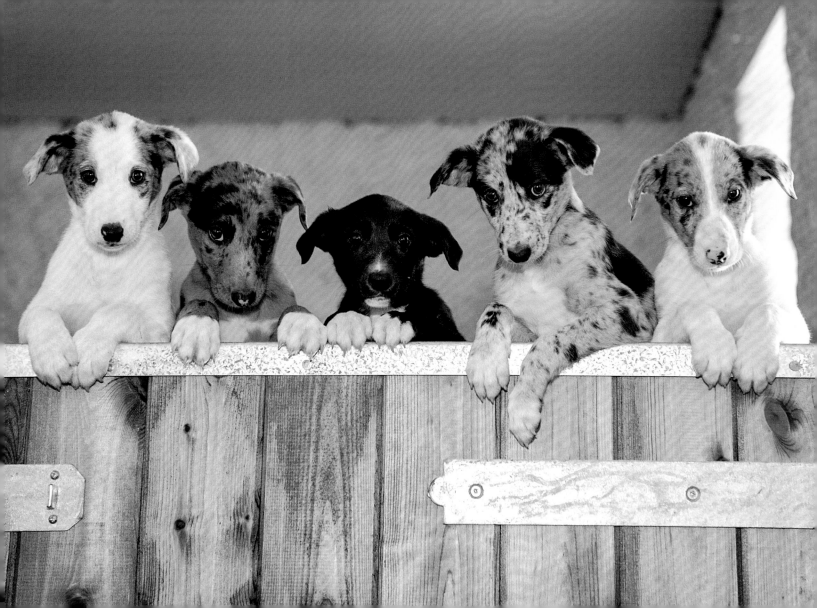

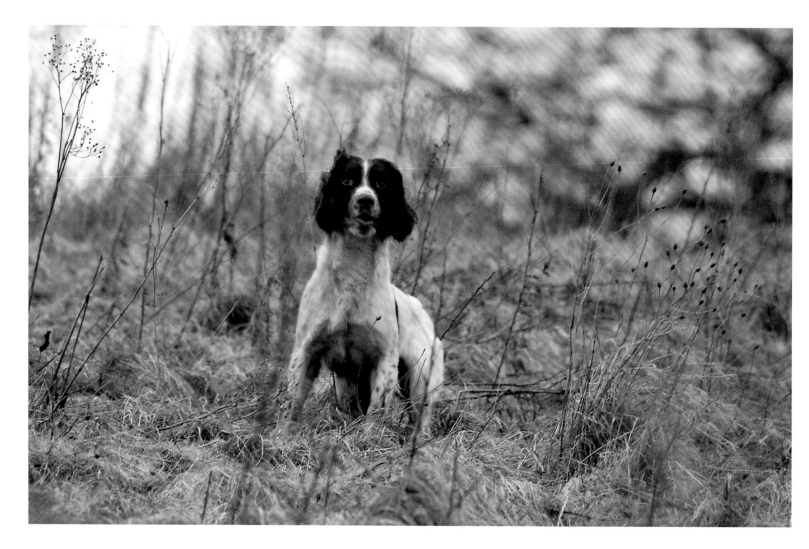

Helmsway Honey waits for directions during the Kennel Club's 78th English Springer Spaniel Championship.

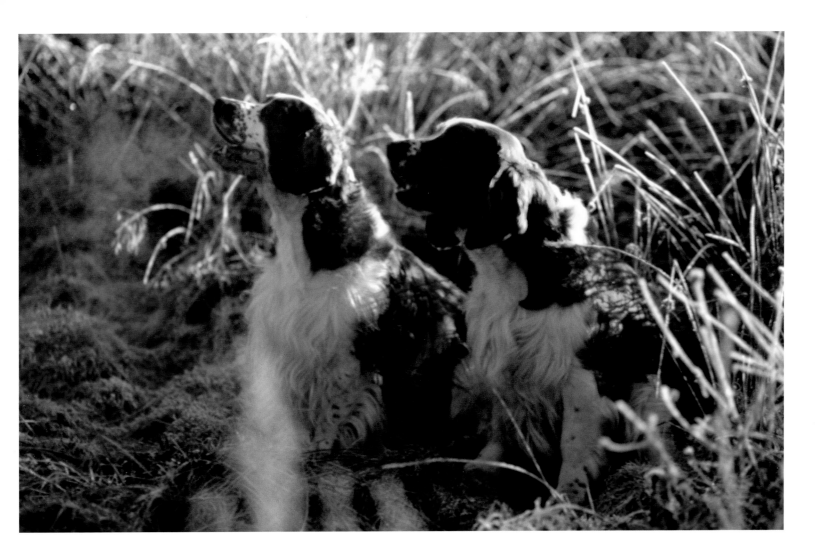

A pair of Welsh springer spaniels

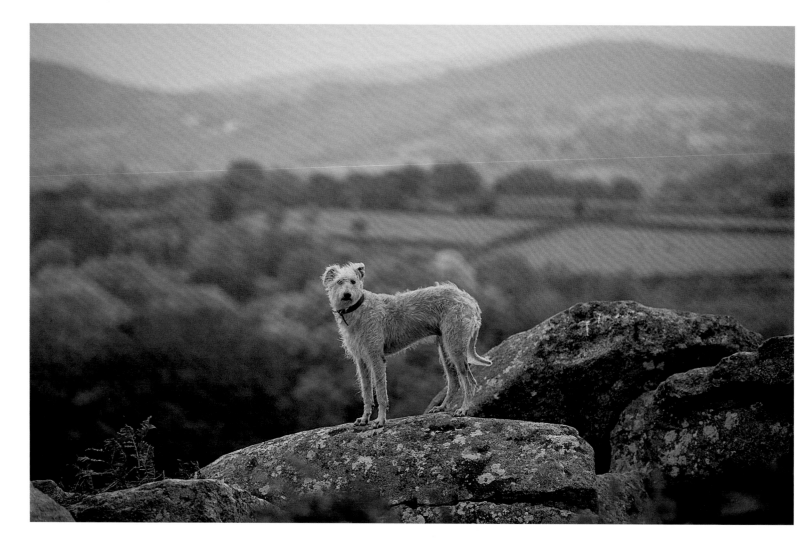

Lurcher

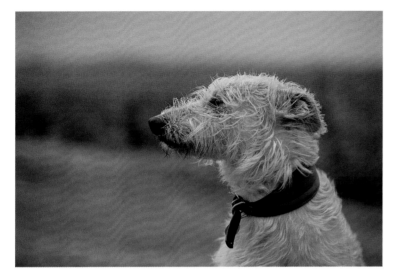

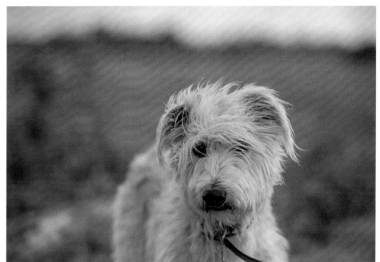

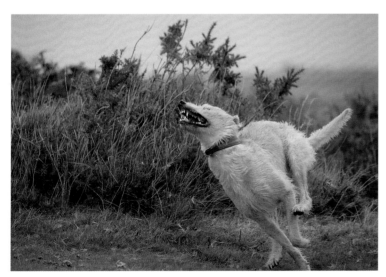

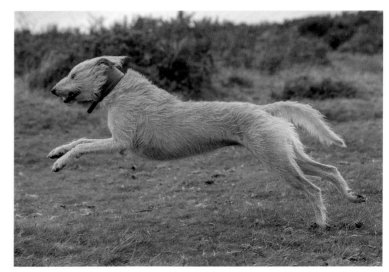

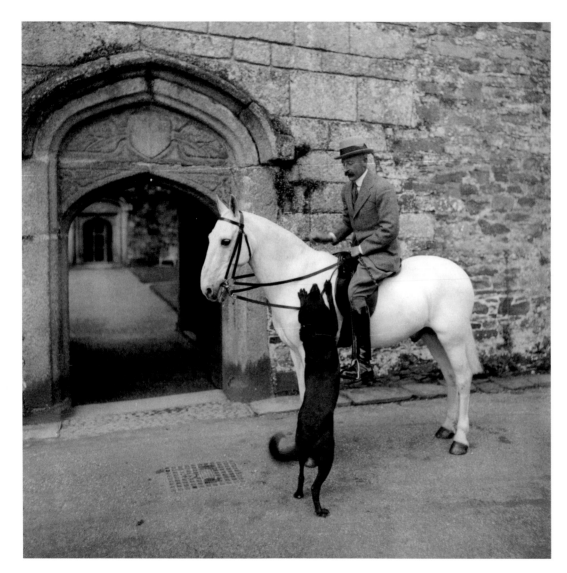

The Earl of Mount Edgcumbe outside
the entrance gate of Cotehele House,
Cornwall, c.1924

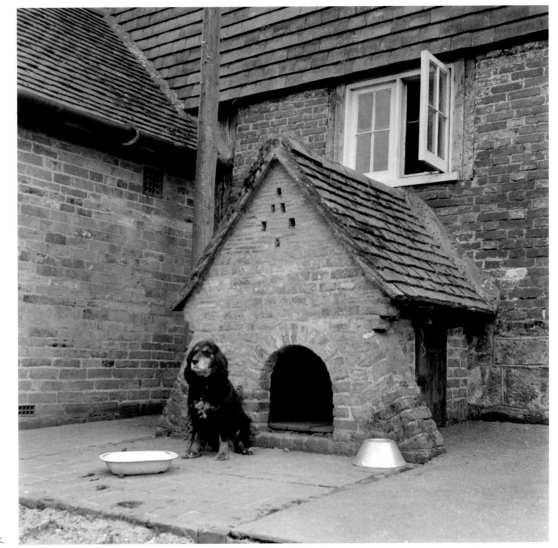

A dog sits obediently outside its kennel,
More House Farm, Wivelsfield, East Sussex.

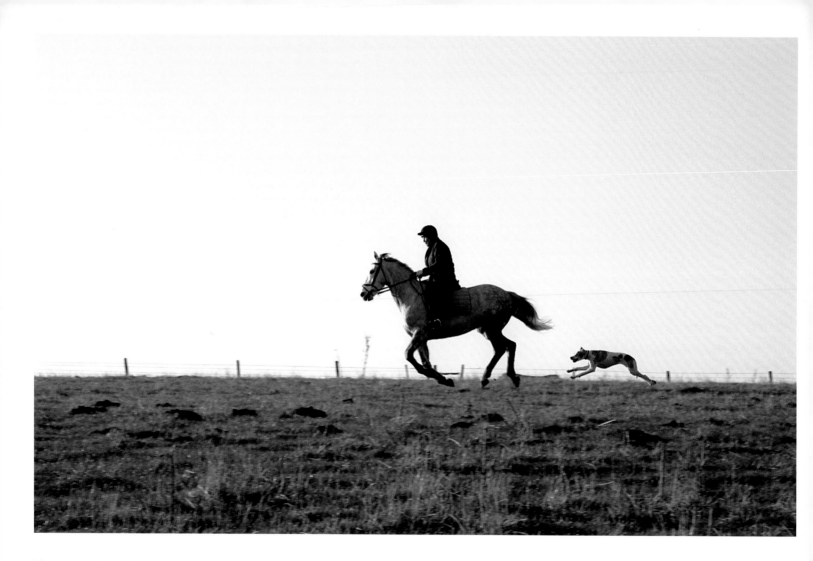

Horse and rider with pointer

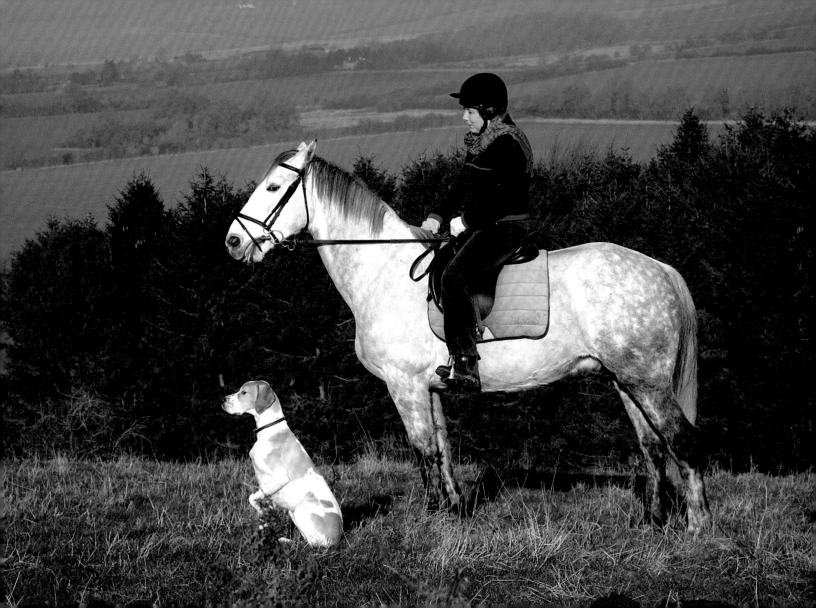

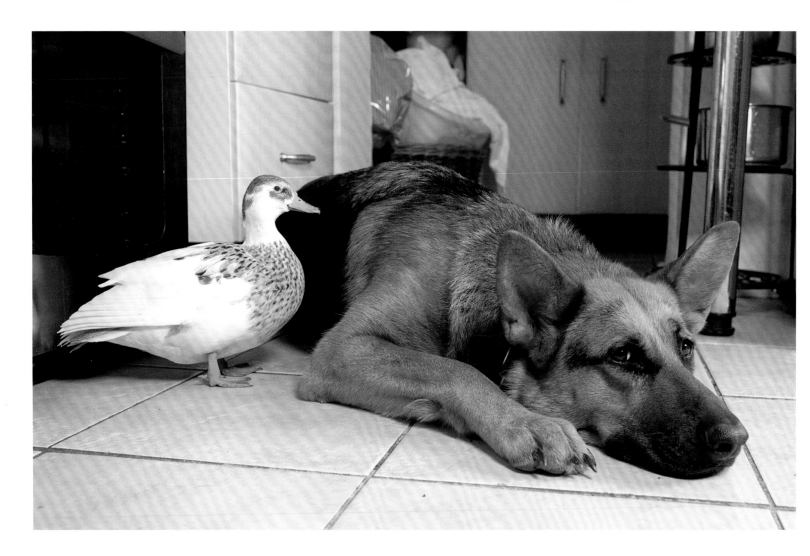

Puddles the duck and Shadow the alsatian

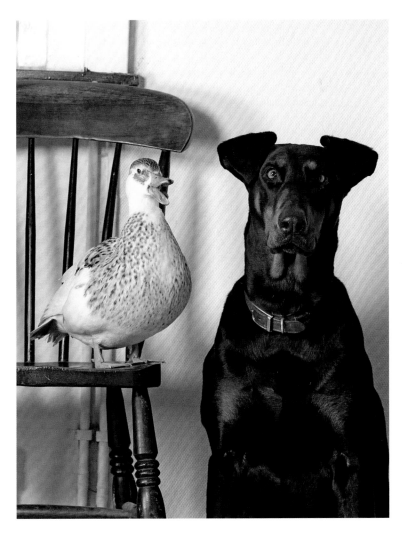

Puddles the duck and Jessie the doberman

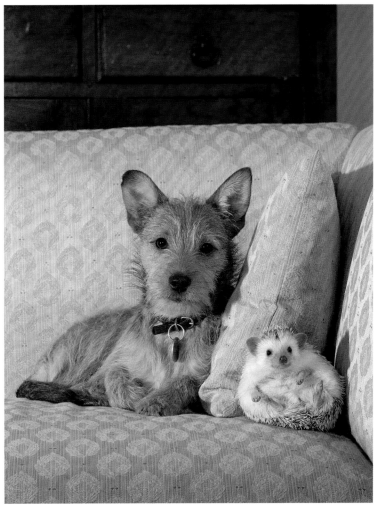

Mini Hog, an African albino hedgehog, and Mary the terrier puppy

Goose, a working cocker spaniel

A working cocker spaniel on the Abbey St Bathans Estate, Berwickshire

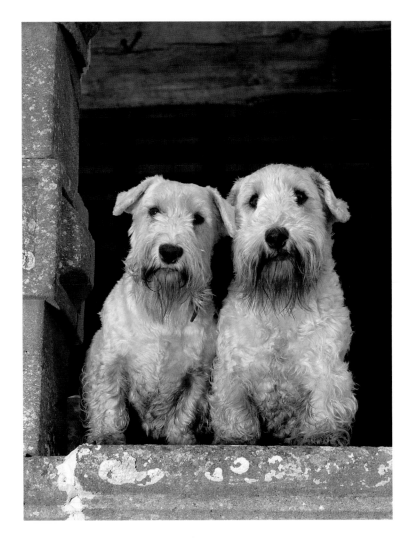

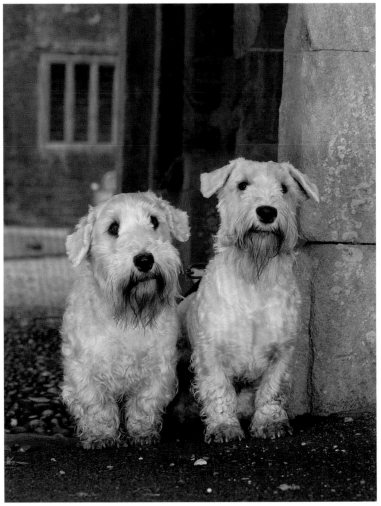

Sealyham terriers

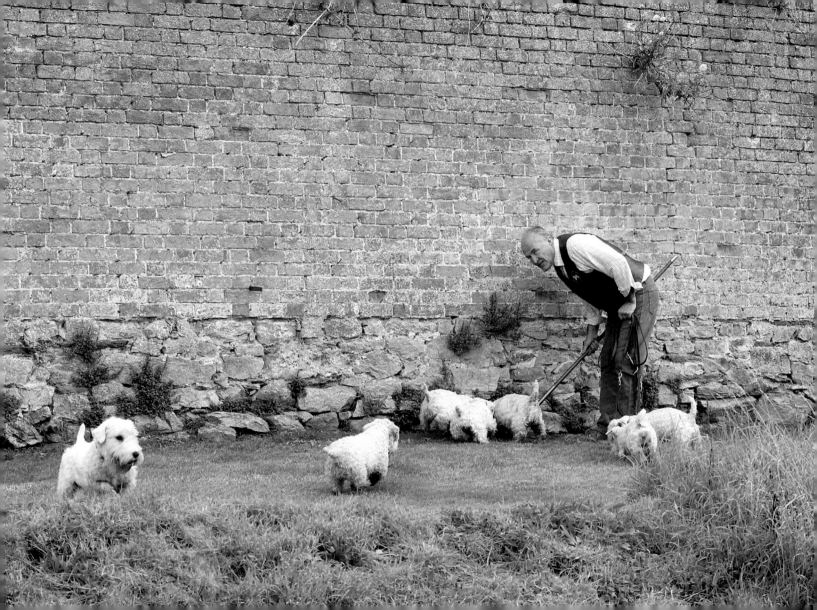

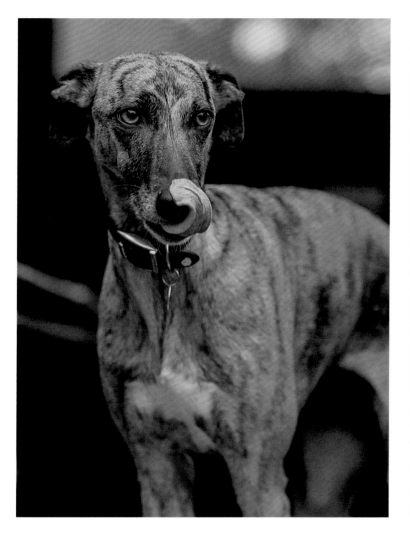

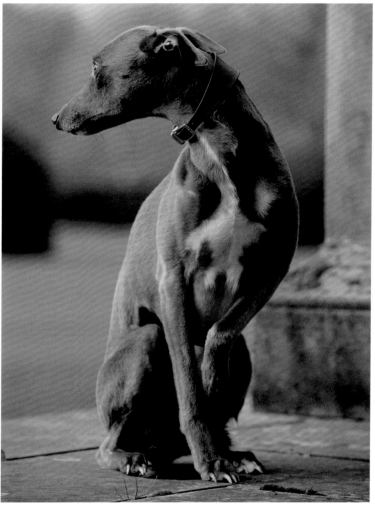

LEFT AND ABOVE: Lurchers

Benjy, whippet, Houghton Hall, Norfolk

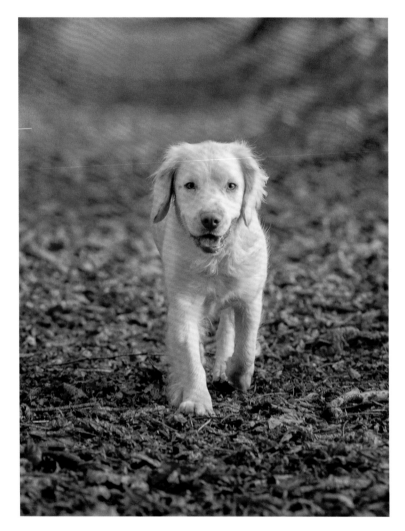
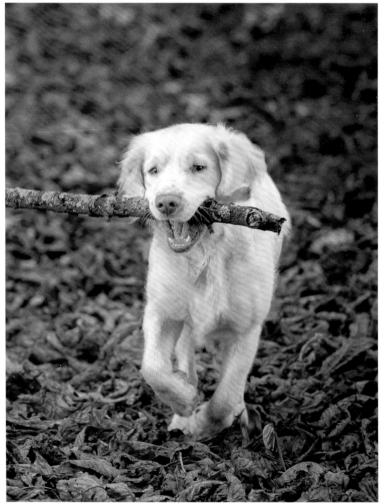

Clumber spaniels, Newbottle Manor, Oxfordshire

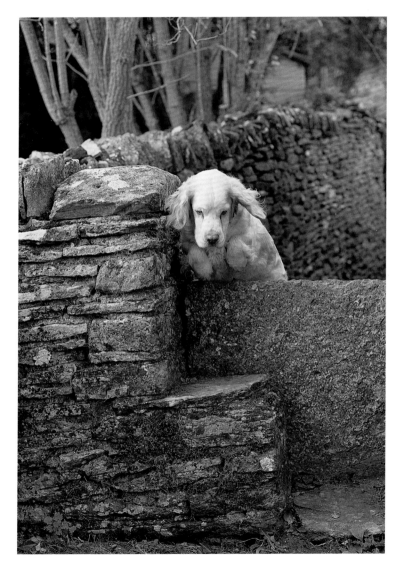
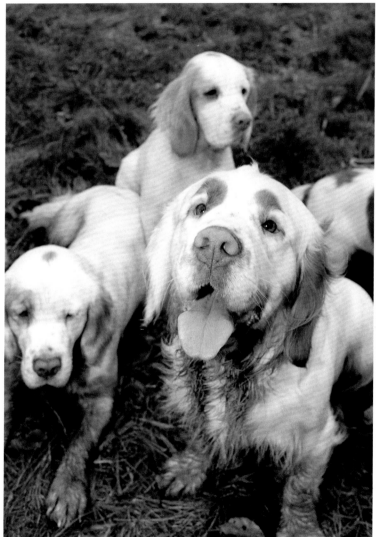

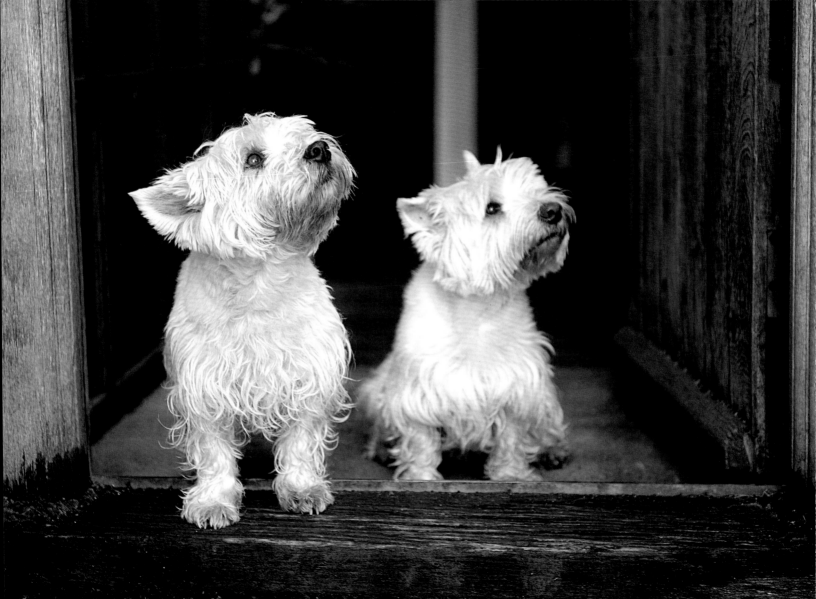

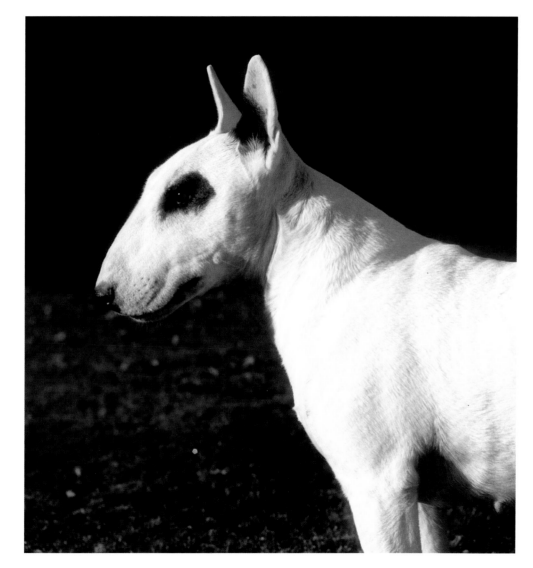

West Highland terriers at Crow's Hall,
Debenham, Suffolk
RIGHT: A prize-winning English bull terrier,
winner of the category at Crufts

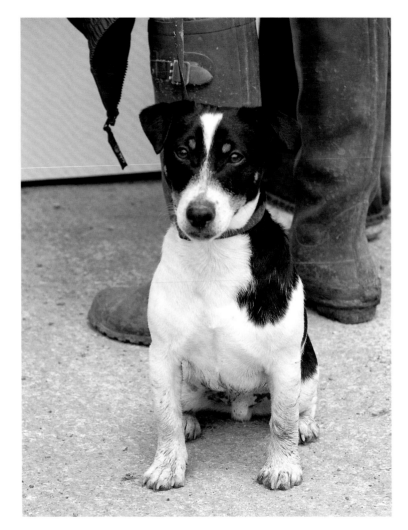

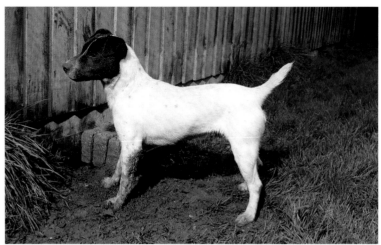

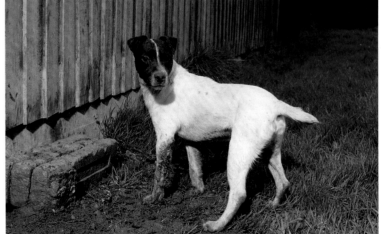

Barney, a Jack Russell

Jack Russells

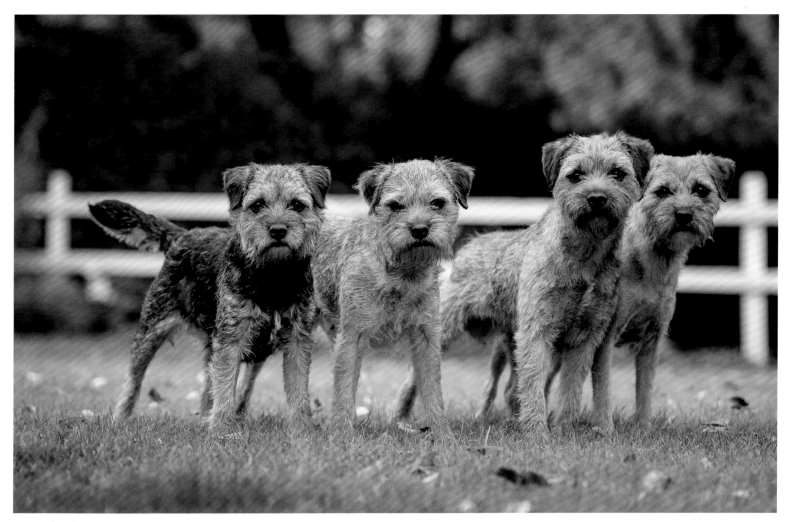

ABOVE: Border terriers

LEFT: Lucy, a Jack Russell who artist Lucien Freud proclaimed had 'a beautiful brow'.

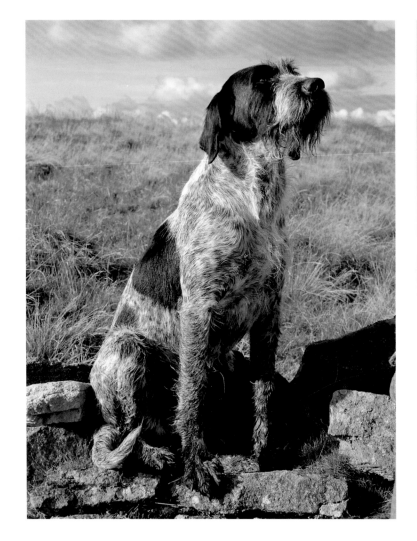

Monty, cross-bred German wire-haired pointer/springer spaniel

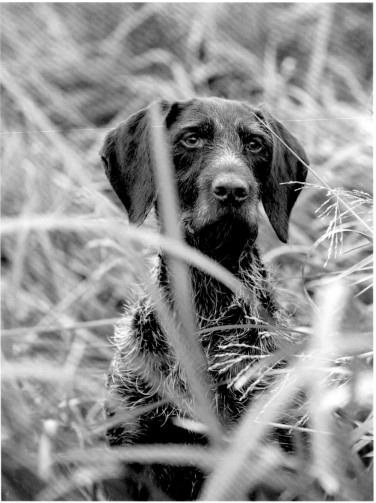

Champion dog Erle, a German wire-haired pointer

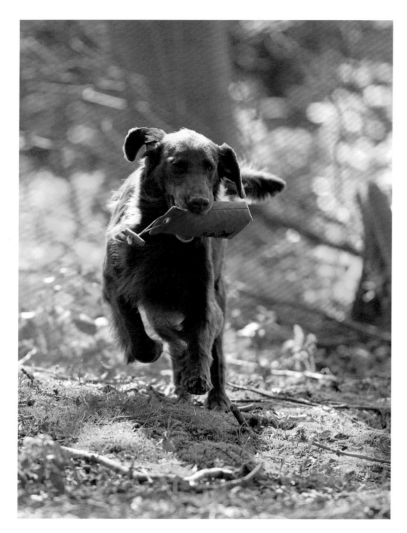

Flatcoat retriever at Castle Howard, Yorkshire

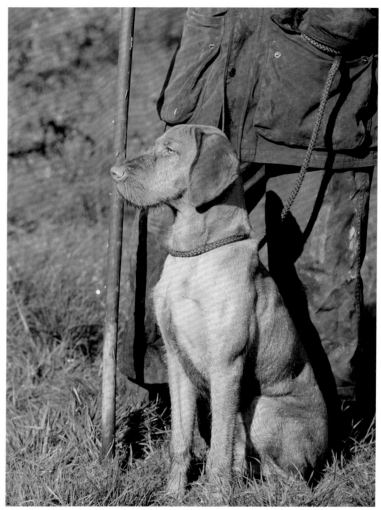

A Hungarian wire-haired Vizsla Gunner sits waiting for action during a pheasant shoot at Peasmarsh.

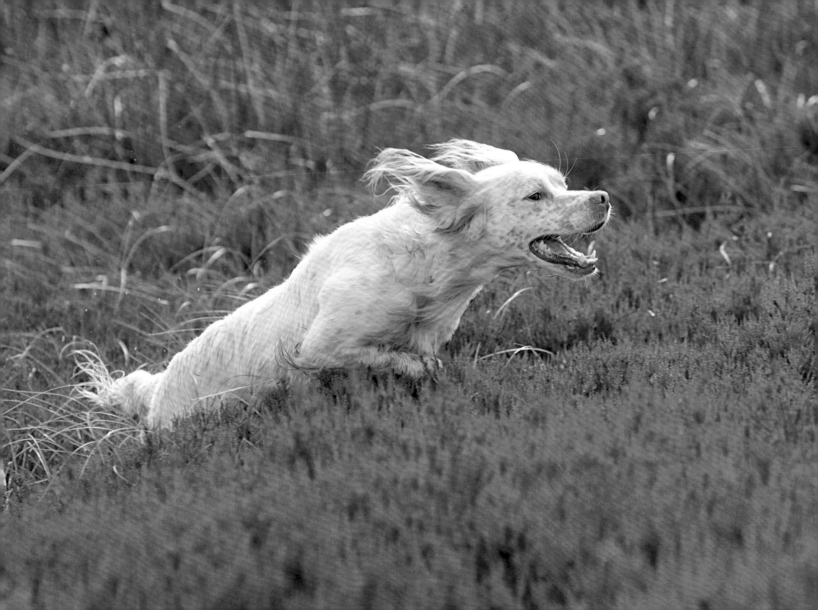

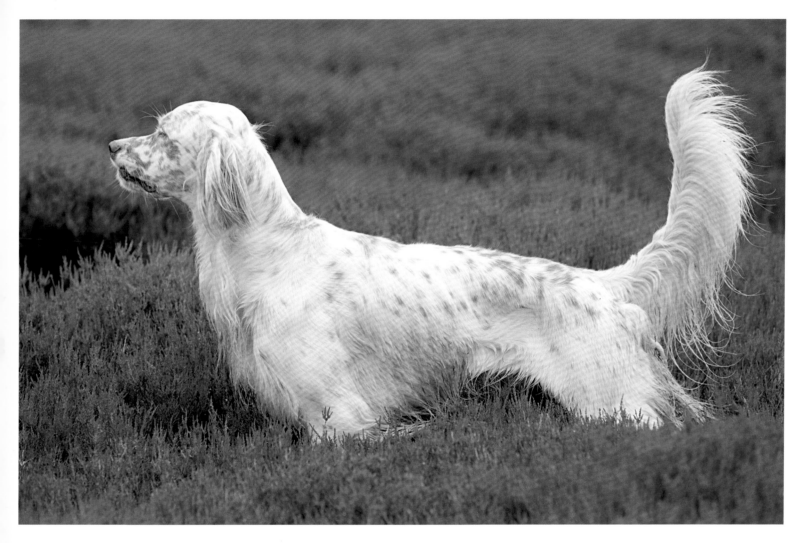

English setters

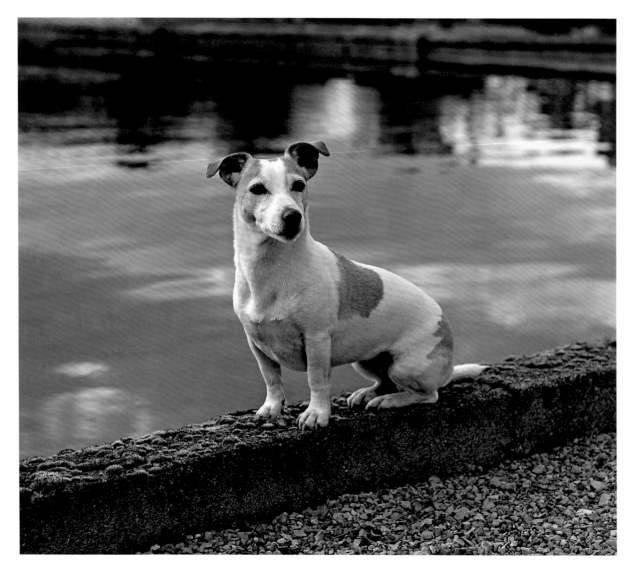

LEFT: Jack Russell, Bramham
Park, Yorkshire
RIGHT: Wolfie, Irish
wolfhound, Errol Park,
Perthshire
FAR RIGHT: Gun dog

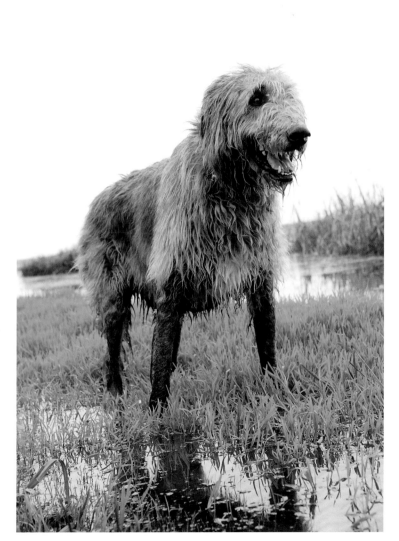
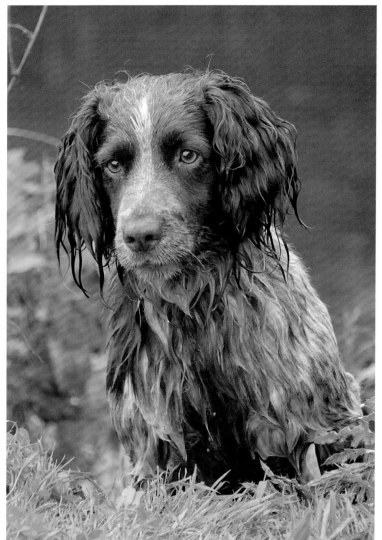

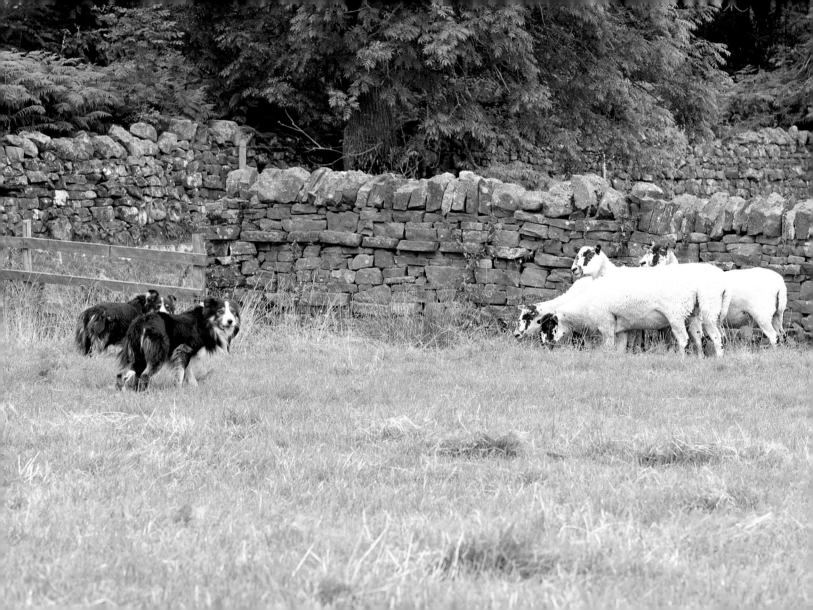

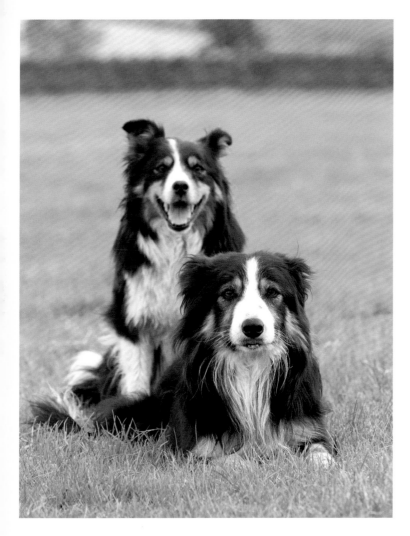
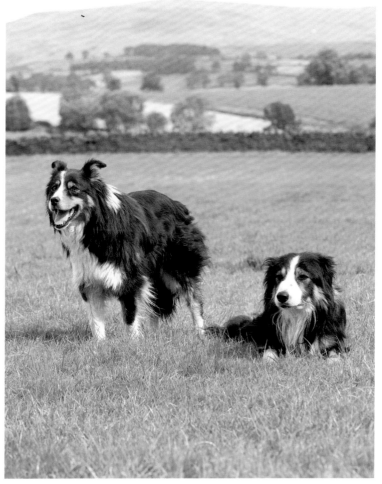

Sheepdogs, Spot and Gail

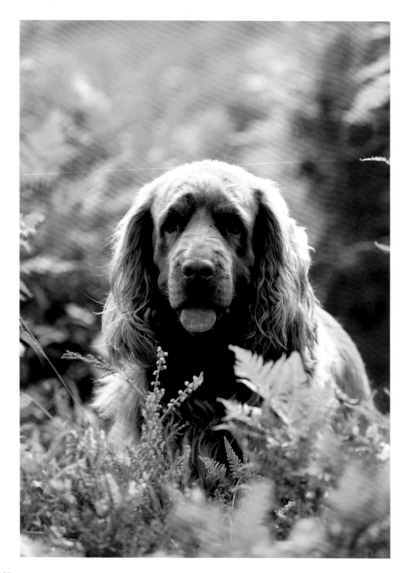

Sussex spaniel

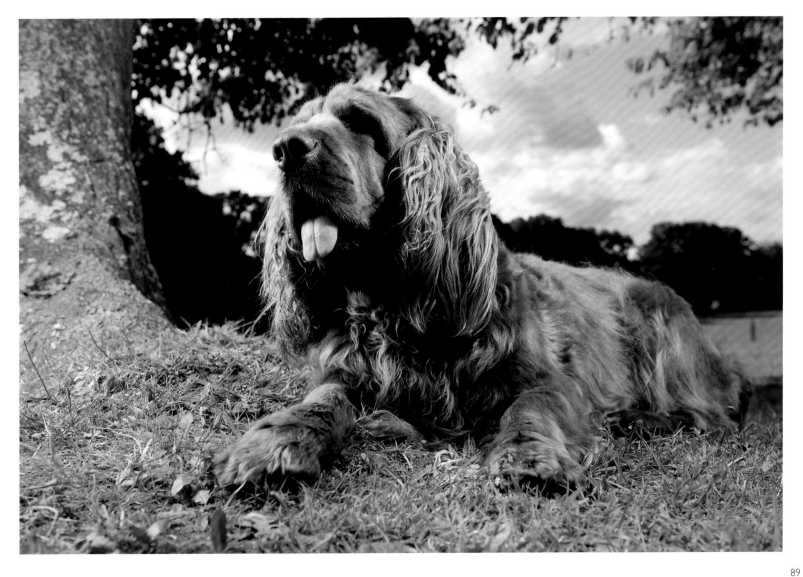

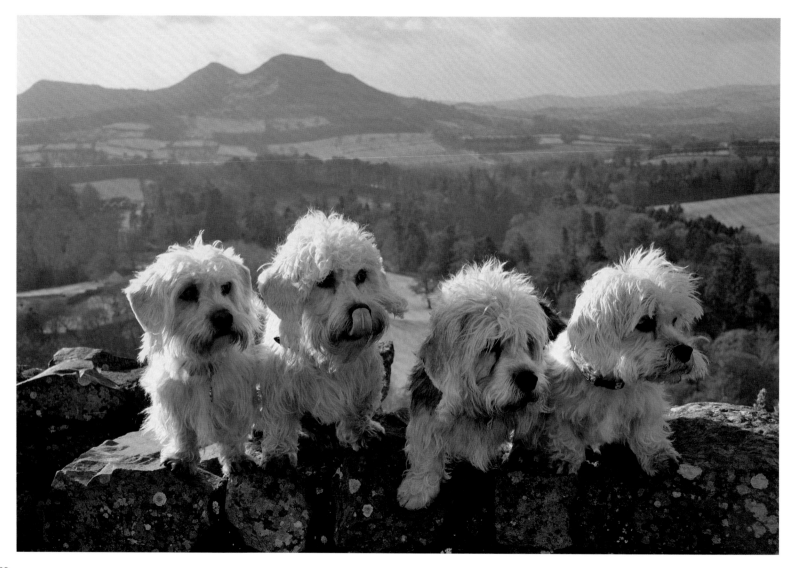

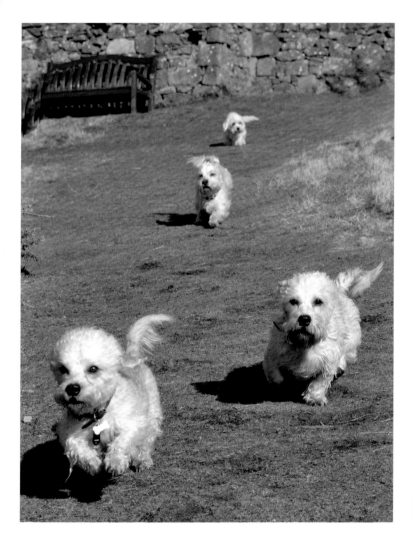

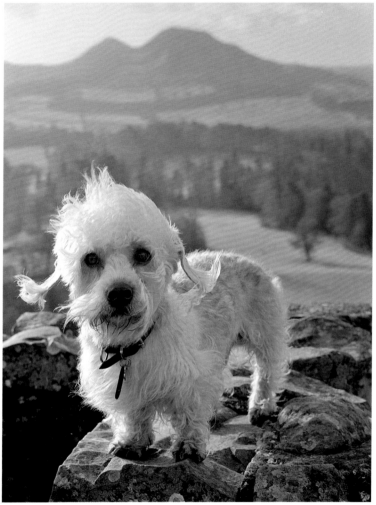

Dandie Dinmonts

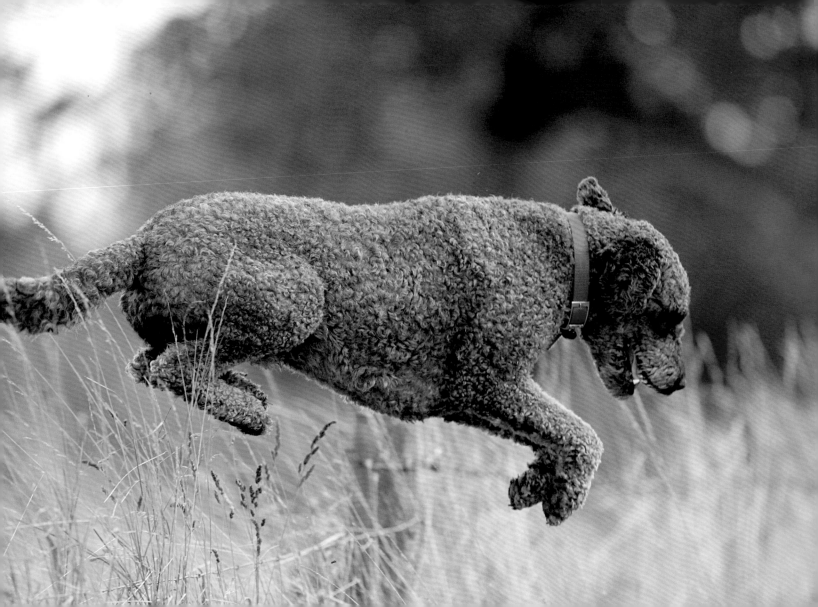

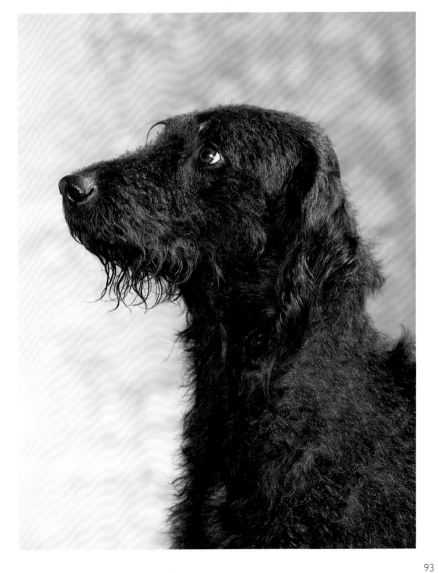

Labradoodles (labrador poodle cross)

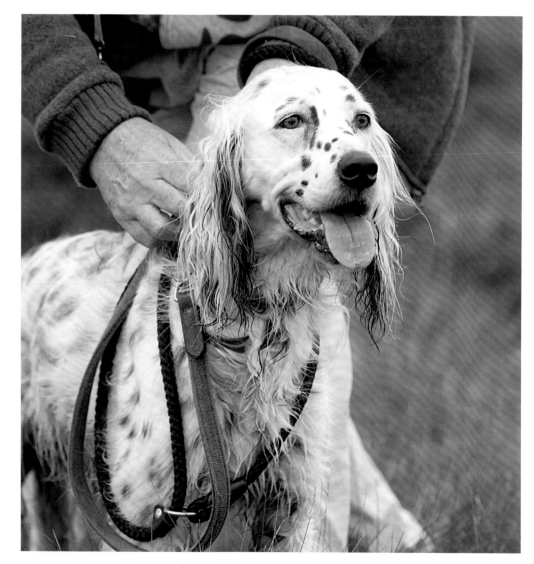

English setters

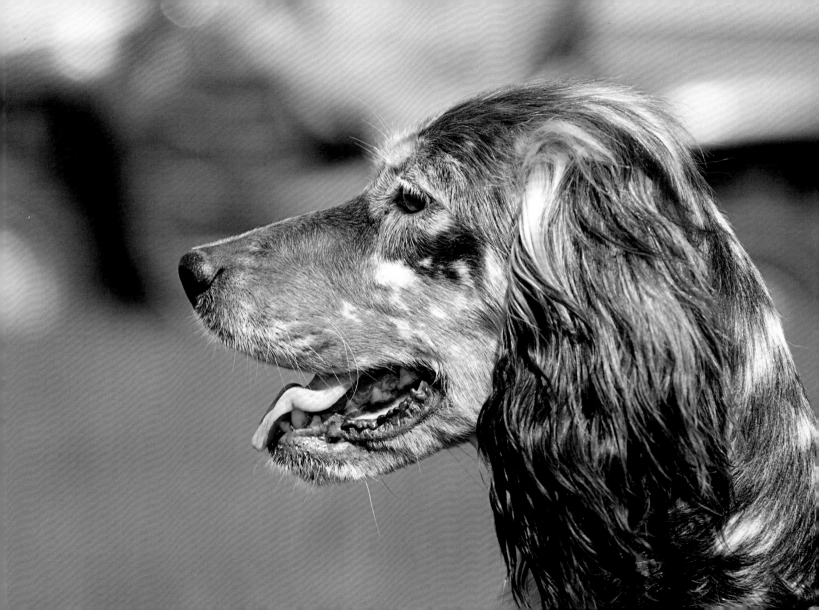

Rabbit, Britain's naughtiest dog, 2015

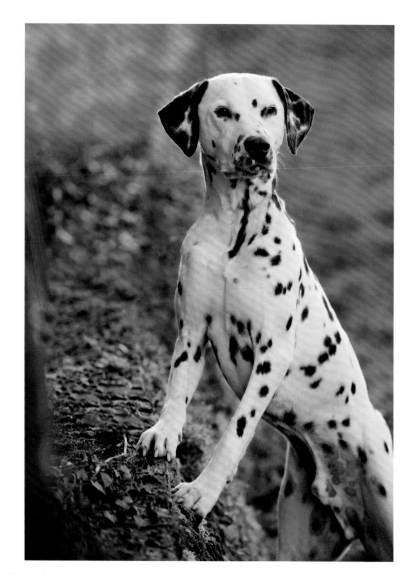

Romeo, dalmation

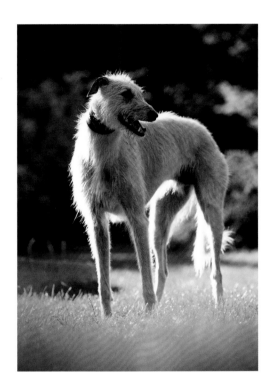 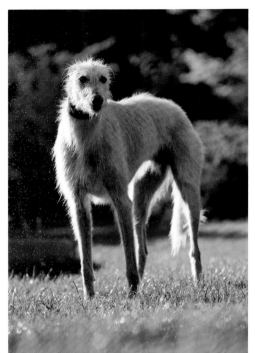 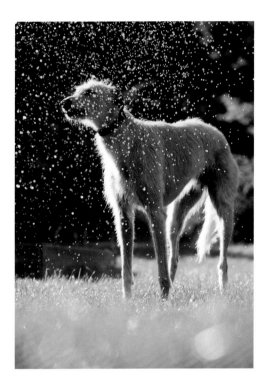

Lizard, lurcher

Dogs at Raby Estate, Durham

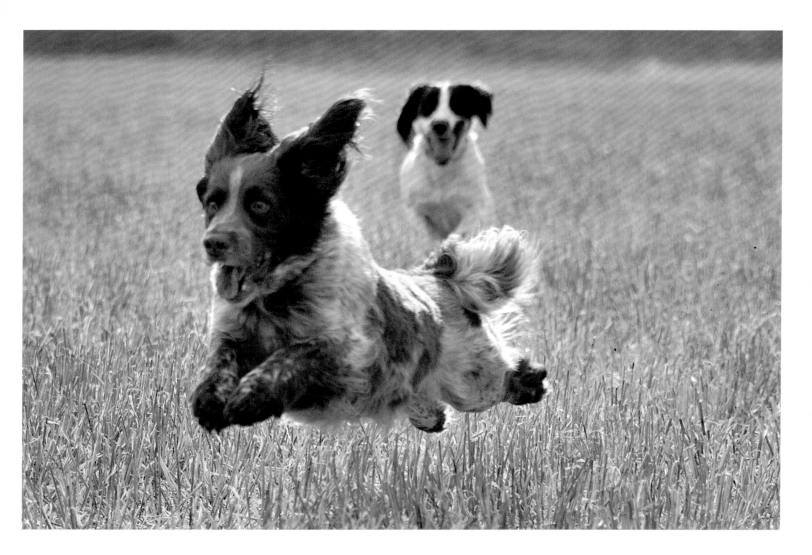

Sprockers (English springer spaniel/cocker cross), Perthshire

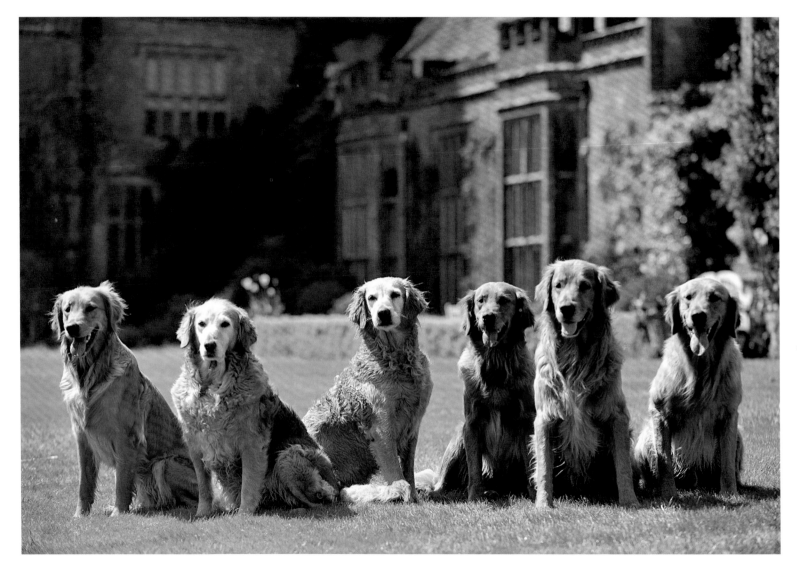

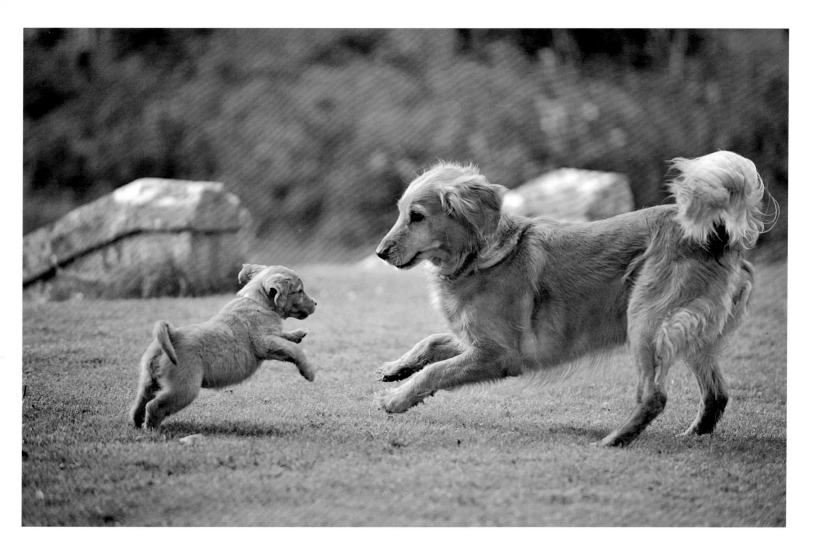

Golden retrievers

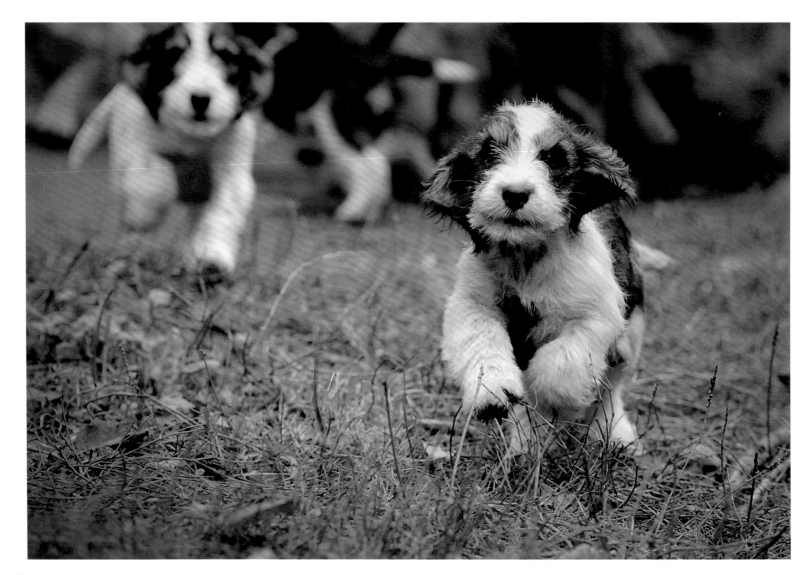

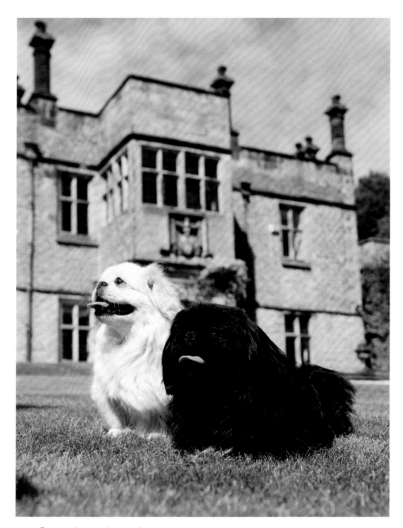

LEFT: Basset hound puppies
ABOVE: Pekingese at Tissington Hall, Derbyshire

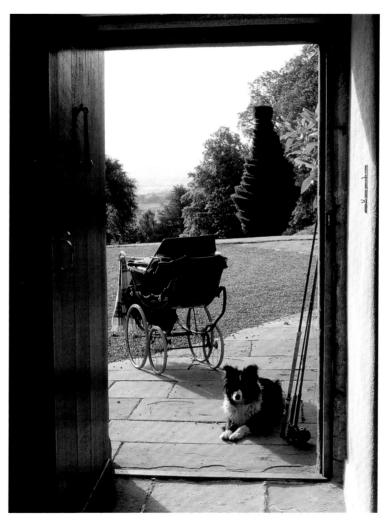

A dog sits outside at Fingask Castle, Perthshire

Labradoodle (labrador poodle cross)

Spanador (spaniel labrador cross)

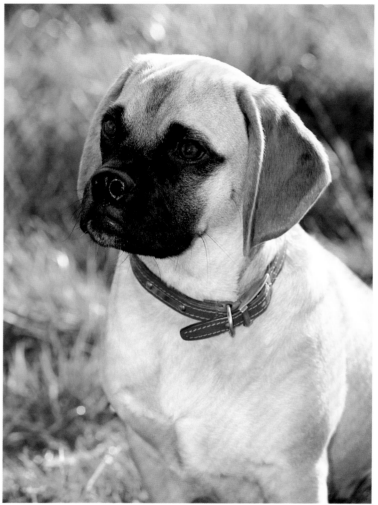

Puggle (pug beagle cross)

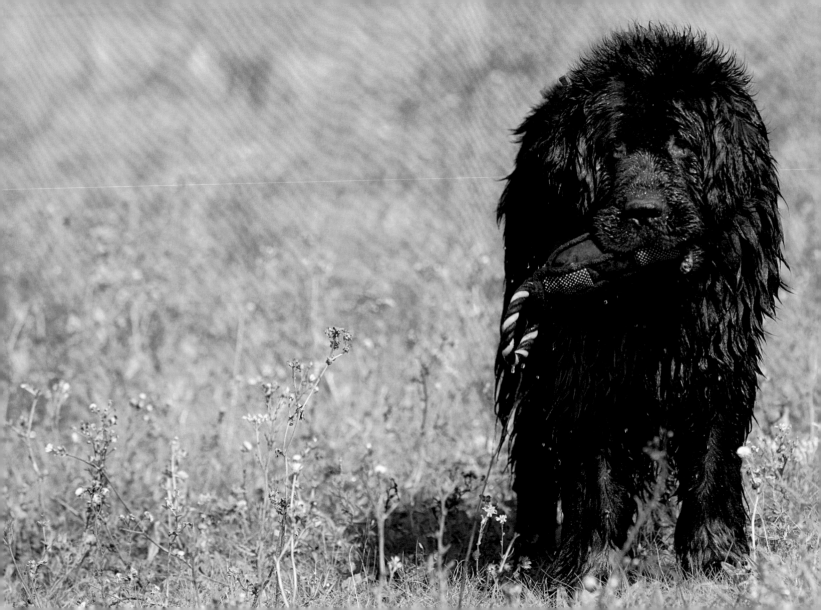

Newfoundland

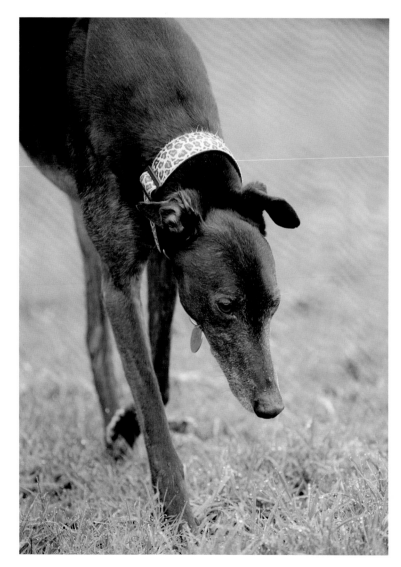

Greyhound

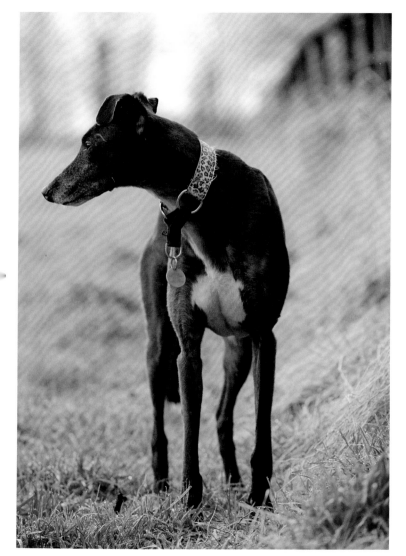
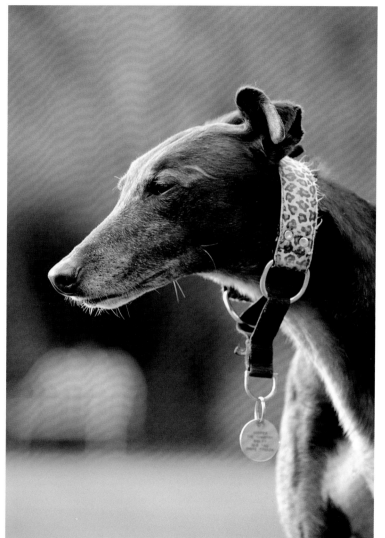

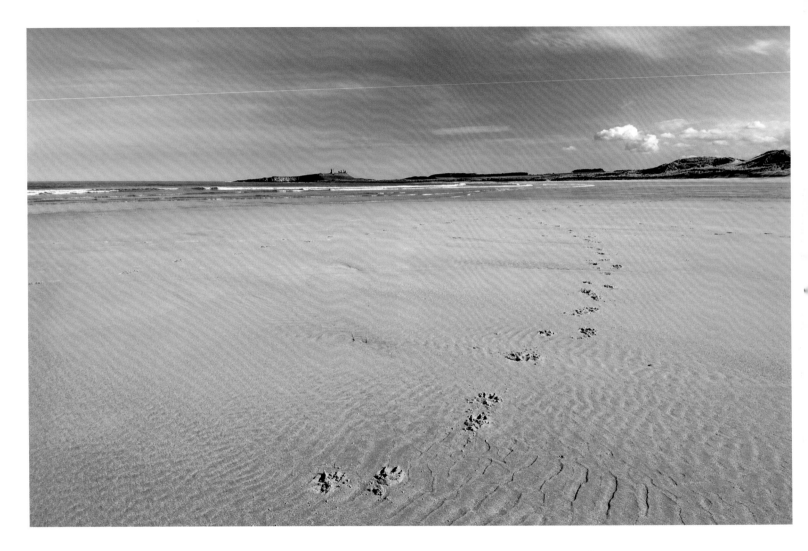

Dog footprints on the beach at Embleton Bay, Northumberland, with the ruins of Dunstanburgh Castle in the distance